S0-BYA-601

Tatjana & Mirabai Blau

Buddhist Symbols

Sterling Publishing Co., Inc.
New York

Dedicated to the Dalai Lama and the Tibetan people in the hope that their country may soon regain its freedom.

Library of Congress Cataloging-in-Publication Data Available

10 9 8 7 6 5 4 3

Published 2003 by Sterling Publishing Co., Inc.
387 Park Avenue South, New York, NY 10016
Originally published by Schirner Verlag
Under the title *Buddhistische Symbole*
© 1999 Schirner Verlag
Landwehrstr. 7a, Darmstadt, D-64293
English translation © 2003 by Sterling Publishing Co., Inc.
Edited by Nancy E. Sherman
Distributed in Canada by Sterling Publishing
c/o Canadian Manda Group, One Atlantic Avenue, Suite 105
Toronto, Ontario, Canada M6K 3E7
Distributed in Great Britain by Chrysalis Books Group PLC
The Chrysalis Building, Bramley Road, London W10 6SP, England
Distributed in Australia by Capricorn Link (Australia) Pty. Ltd.
P.O. Box 704, Windsor, NSW 2756, Australia

Printed in China
All rights reserved

Sterling ISBN 1-4027-0033-4

Contents

Introduction

This book provides an overview of the symbols of Buddhism. We have chosen not to make it comprehensive, but to include the most significant symbols, and the ones selected here are primarily those of Tibet.

A short outline of the history and philosophy of Tibetan Buddhism follows. The emergence of this religion is discussed in greater detail beginning on page 11.

Buddhism began to trickle into Tibet by the third century A.D. and it prevailed there briefly under King Trisong Detsen (r. 755–797) in the eighth century. Only fifty or so years later, during a period of civil strife under King Lang Darma, the religion came under attack and its adherents were persecuted. Buddhism was then all but wiped out.

At the end of the tenth century, Buddhism was resurrected in Tibet through the work of missionary monks from India. The translation of Buddhist texts (*sutras*) into Tibetan, which had commenced earlier and then been abandoned, resumed in earnest, and concluded with the publication of the Canon of Tibetan Buddhism in the 13th century. This translation was critical because at the same time, Islamic conquerors were destroying the original texts.

Tibetan Buddhism, also called the Diamond Vehicle (*Vajrayana* in the original Sanskrit), is rooted in the *Vajracchedika Prajanaparamita* sutra, which means The Perfection of Wisdom That Cuts Like a Diamond. Adherents seek knowledge of the infinite energy by letting go of

worldly realities. This is accomplished by overcoming the habitual way that humans see reality and recognizing that nothing exists except pure consciousness.

To achieve this state, Tibetan Buddhism offers rituals that underscore the oneness of body, speech, and mind. Among these rituals are *mudras* (symbolic hand gestures), *mantras* (symbolic words), and *mandalas* (symbolic icons). The key symbol of Tibetan Buddhism—a ceremonial scepter—is the *Vajra* (diamond or thunderbolt in Sanskrit).

A text of central importance to Tibetan Buddhism is the Book of the Dead. Known in the Tibetan language as Bardo Thodol (literally, Liberation by Hearing on the After-death Plane), it describes the stage between death and subsequent rebirth. Despite its name—the text is usually read to people on their deathbeds—it is a book for the living, as well. Its message is that the confusions of life stem from the dualistic way we perceive the world. The Bardo Thodol is instructive in how to think not dualistically, but holistically, thereby transforming confusion into wisdom.

Buddhas and Bodhisattvas

Buddhas

A buddha is a completely enlightened entity with an all-encompassing understanding of nature and reality. This wisdom is combined with universal compassion and unlimited capacity for understanding other realities.

A buddha is filled with *bodhicitta*, the spirit of enlightenment and compassion. This state is reached by wholly dedicating himself to fulfilling the needs and assuring the well-being of all living entities. In this state, he enjoys freedom from suffering and the insight to help other living beings find their way out of *samsara*, the never-ending cycle of death and rebirth that is the consequence of *karma*.[1]

Such buddha-states have two phases. In the first, having achieved the liberating state of enlightenment and the insights thereby gained, a buddha is in a pre-death state known as *nirvana*. Here he enjoys liberation from the bondage of samsara and the extinction of passion, illusion, desire, and self in exchange for rest, truth and changeless being. Once the old karma is overcome, a buddha reaches a more perfect state, which has no words to describe it. From this point on, no living beings are able to reach him.

Buddhas do not intervene directly in the lives of those who seek enlightenment. They simply teach the way of Buddhism and its spiritual goals by example. They support

[1]*Karma is a kind of "fate account" where, over several lifetimes, good and bad actions are listed. They will be the factors that decide if the owner of the account has to return to samsara and into what stage.*

8

people on the journey to enlightenment by pointing them in the right direction, but they do not lead them. Buddhas demonstrate the right way by example, and in their behavior and attitude illuminate the path to knowledge. The buddha does not serve as practical support—this is the job of the *bodhisattva* (see page 43).

The Three Paths of Buddhism

In Buddhism there are three ways of finding release from samsara, the cycle of death and rebirth:

Hinayana—the Lesser Vehicle—is primarily practiced in Thailand, Sri Lanka, Laos, Burma, and Cambodia. In this school, a person seeking an end to samsara is concerned mostly with his or her own release from the cycle.

Mahayana—the Greater Vehicle—is practiced mostly in China, Nepal, Vietnam, Korea, and Tibet. In this school, a person is seeking his or her own release from samsara but will also support all other living beings on the journey as a bodhisattva.

Vajrayana—the Diamond Vehicle—is the way of Tibetan-Tantric Buddhism. While an adherent of this school ultimately seeks his or her own release from samsara, he makes a commitment not to enter nirvana until all other beings are likewise freed. Until then he will continue to be born again and again and to support others on their journey, as an Enlightened One, or bodhisattva.

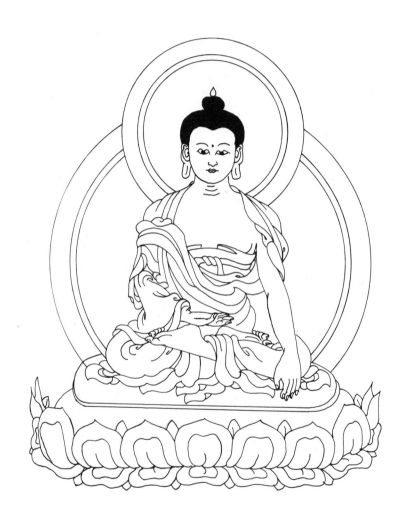

Shakyamuni, the Buddha of the Present Era

Gautama Buddha

Siddhartha Gautama lived about 2,500 years ago in India, in the northern state of Bihar. His father ruled a small kingdom of the Shakya clan. For a good part of his life, Siddhartha Gautama lived in seclusion in his father's palace. There, he even married and fathered a son.

It had been prophesied at his birth that he would become either a great monarch or, affected by the suffering he saw in the world outside, a great religious leader. His father determined to keep the unkind realities of life outside Prince Gautama's experience so as to make him a monarch rather than a saint, but it was inevitable that he would encounter them eventually.

A chariot ride through the city in which he had lived in utter luxury and isolation to the age of about thirty changed his life. There for the first time he encountered the woes of man—weariness, disease, and death—and was so moved that he renounced his life of privilege and power to wander the world in search of an end to the misery and pain of all living things.

He wandered for six or seven years throughout India, meditating and praying, meeting and questioning all the recognized sages of the time. He met a group of ascetics whose search for truth entailed harsh physical exercises, self-flagellation, and meditation. Siddhartha joined them for a time and practiced their harsh rituals until he lost confidence in their methods. In frustration and disappointment, he sat down under a bodhi tree outside the city of Gaya (Bodhgaya) to meditate, resolved to find the truth. One

11

night, enlightenment came—he found the knowledge that can only be found within.

But Siddhartha realized that human beings are inherently averse to accepting this knowledge and he thought better of starting to teach it. Rather, he returned to the solitude of the forest where, for three weeks, he immersed himself in his new wisdom. There he was approached by two of the highest deities in Buddhism, Indra and Brahma. Both brought him gifts: Indra, a large white conch shell; and Brahma, a golden wheel with a thousand spokes. These gifts symbolized the turning of the dharma wheel that made disseminating Buddha's teachings possible.

Recognizing the gifts as an appeal that he use his teachings for the benefit of all living beings, Siddhartha left the forest and traveled to Sarnath, near Varanasi in India. There he gave his first sermon, expounding on the four noble truths and speaking for the first time of nirvana. In essence, he said that it is possible to reach the freedom of nirvana only with the knowledge that:

1) There is suffering.
2) There is a cause of suffering.
3) Suffering can be overcome.
4) There is a way to overcome it.

These are the four noble truths and the first step on the way to release from samsara in the journey toward enlightenment and emptiness (*sunyata*).

He thereafter became known as the Buddha, the Awakened One, or Shakyamuni, meaning The Wise Shakya or Sage of the Shakyas. By whatever name he is called, his life and teachings became the heart of Buddhism. As the buddha of the present era, he traveled all over India for over 40 years,

helping others by sharing his message, until his death around 480 B.C.

Gautama Buddha is usually depicted in a simple monk's robe, with skin the color of gold. Elongated ear lobes are a sign that he is able to listen inward. A small curled strand of hair between his eyebrows signifies the eye of wisdom and the turban on top of his head is a sign of the Buddha's enlightenment.

Buddha recognized how fleeting and interdependent is everything in life. He taught that the world and all living beings are connected in physical body, mind, and spirit, guided by intuition, emotion, and conscious action. He explained samsara, the never-ending cycle of death and rebirth. He believed that this cycle continues as long as greed, hate, and envy reside in a person's heart.

Buddha taught that life is change. Though the flowing waters of a river appear to be always the same, they are in fact constantly changing. And so is life—a never-ending, always-renewing stream of all the elements of existence that even death cannot change or interrupt. Life is determined by karma—a human being is what he was and will be what he is. The goal is to leave this cycle and achieve nirvana.

The teachings of Gautama Buddha comprise a system of revelation that leads to the end of suffering. A disciple reaches his goal through meditation, strict moral behavior that avoids causing suffering to others, and deep insight into the true nature of reality.

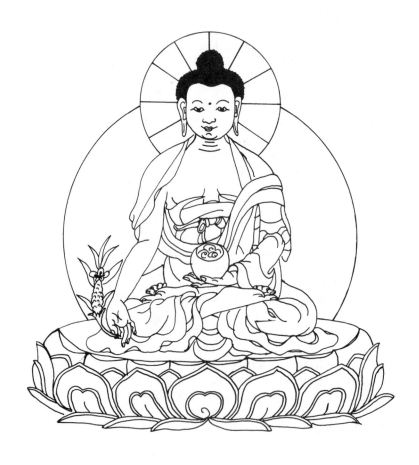

Bhaisajyaguru, the Medicine Buddha

Bhaisajyaguru

The historical Gautama Buddha is usually depicted sitting in the center of eight medicine buddhas, or *Bhaisajyagurus.* A medicine buddha is also called the King of Healers or the Most High Healer.

The buddha on the opposite page is the one most often seen. His skin is deep blue, the color of lapis lazuli, indicating enlightenment. In the right hand he holds a stem of the mystical plant, *myrobalan* or cherry plum (Latin, *Terminalia chebula*; Tibetan, *arura*). In the left hand he holds an iron bowl filled with *amrita* (divine healing nectar). Multicolored rays emanating from his body help banish the three poisons—desire, hatred, and envy—and harmonize and reestablish the balance between the three humors—wind, bile, and phlegm.

Another form of the Bhaisajyaguru is often depicted with the right hand in the Gesture of Meditation, while the left hand is holding a begging bowl filled with nectar and the same healing plant, myrobalan. Often his hands are held in the Gesture of Inner Balance (*dhunana* mudra, page 95), in which both right and left hands are resting in the Buddha's lap with palms facing up and fingers fully extended, holding a begging bowl filled with ambrosia and myrobalan.

Meditating with a medicine Buddha creates great therapeutic energy, which is useful for healing oneself and others.

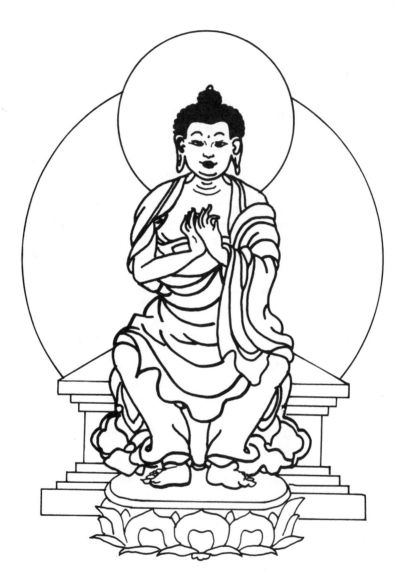

Maitreya, the Buddha of the Coming Era

Maitreya Buddha

Buddhas who have reached perfect enlightenment reside for a time in the Manorama-Paradise, a part of the peaceful Tushita heaven, where they proclaim the dharma to the deities, angels, and saints before returning to earth in the forms of the most prominent Buddhas to serve as religious leaders.

When Gautama Buddha left there to teach on earth, Bodhisattva Maitreya became the ruler and teacher in the Manorama-Paradise. Some time in the distant future, he too will return to earth. In fact, it is believed that he may already be here in the guise of a helping being. The great fourth-century master Asanga insisted that he met Maitreya personally, and that the Buddha led him to Tushita, where he was given the five sacred manuscripts he brought back with him to India. These manuscripts are the foundation of the Law of Great Compassion, one of the most important stages on the path to enlightenment.

A monastery in the vicinity of Lhasa, the capital of Tibet founded by Tsongkhapa in 1415 (see page 205), was named after the Tushita heaven (in Tibetan, Ganden). The name was chosen to express hope that the Maitreya Buddha will indeed some day return to earth.

The position of the figure's hands is symbolic of the first sermon given by Gautama Buddha following his enlightenment. Thus, it has come to betoken the setting into motion of the wheel of dharma teaching; the gesture is called *dharmachakra* mudra. In this mudra, the thumbs and index fingers of both hands touch at their tips to form a circle,

representing the wheel of dharma. The hands are held in front of the heart, indicating that the teaching comes straight from the Buddha's heart. In some depictions, the Buddha is holding the stem of a lotus flower. The image is a sign that it is the Buddha Maitreya, also known as the Laughing or Benevolent Buddha, who will set the wheel in motion again.

Until his return to earth the wheel will not move. In some cases he is depicted with the right hand in the Gesture of Protection (*abhaya* mudra, see page 96), and the left hand holding a container filled with nectar, symbolizing that he will once again show the path to enlightenment.

Primordial Buddhas

Early texts of the Hinayana (Lesser Vehicle, also known as Theravada) already mention six Buddhas who preceded Gautama Buddha. This means that the teachings of Buddhism are much older than originally assumed. All told, there were 24 primordial Buddhas, but only six are known by name. It is believed that they lived here on earth as human beings.

Their identifying features (a protuberance on the top of the head as a sign of enlightenment, a third eye, elongated ear lobes) are identical to those of Gautama Buddha. They differ only in mudras (see page 94).

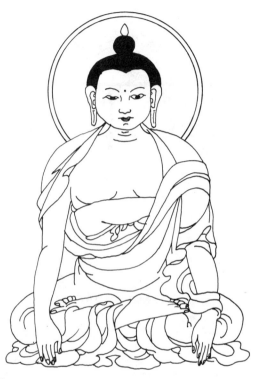

Vipasyin

This primordial Buddha is also known as the Clear-Sighted for his "steadfast gaze" at the bodhi tree. He reached enlightenment while meditating under a patali tree. His hands are in the Gesture of Witness, also known as the Touching the Earth or *bhumisparsha* mudra, in which all five fingertips touch the ground. The gesture symbolizes the Buddha's enlightenment, when he summoned the earth goddess, Sthavara, to bear witness to his attainment.

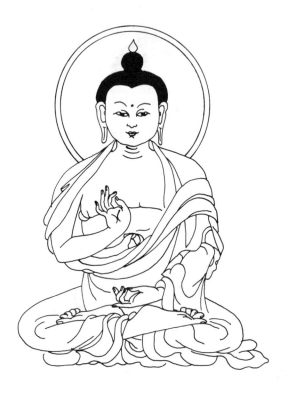

Sikhin

This Buddha reached enlightenment under a large lotus flower. He is distinguished from other primordial Buddhas chiefly by the mudra, the position of his hands. The right hand is held in the Gesture of Debate or Intellectual Argument (*vitarka* mudra) and the left in the Gesture of Teaching (dharmachakra mudra).

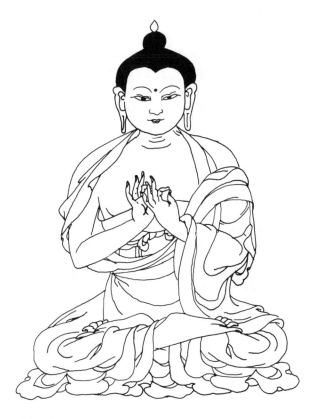

Visvabhuj

This Buddha reached enlightenment while sitting under a salamander tree. His distinguishing mudra is the Gesture of Teaching (dharmachakra mudra), which indicates that he is setting the dharma wheel in motion.

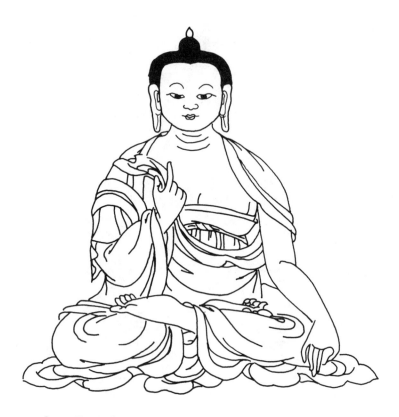

Krakucchanda

This Buddha is the first of our present age. He reached enlightenment under a sirisa tree. He is depicted with his left hand in the Gesture of Charity (*varada* mudra), his right hand holding part of his shawl.

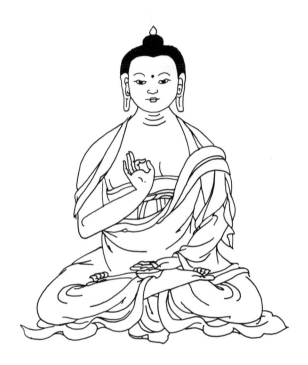

Kanakamuni

Translated, this Buddha's name means Golden Wisdom because legend has it that on the day he was born, gold poured down from heaven. His tree of enlightenment was the *Udumbara*. His right hand is held in the Gesture of Intellectual Argument while the left is resting in his lap, palm up, in the Gesture of Leisure, which distinguishes him from the primordial Buddha Sikhin (see page 20).

23

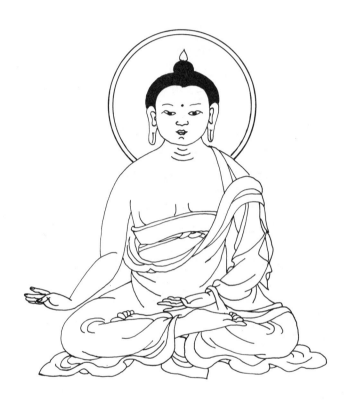

Kasyapa

Kasyapa, the last of the primordial Buddhas, reached enlightenment under a banyan tree. His distinguishing mudras are the right hand in the Gesture Beyond Misery, an ascetic's gesture of renunciation (*buddhashramana* mudra), and the left hand resting, palm up and fingers extended, in his lap.

Ancient or Adibuddhas

Dharmakaya is the formless aspect of the Buddha's being, a thing beyond all ideas and concepts, all images and forms. It is eternal and self-created, said to have been revealed in the form of a blue flame emerging from a lotus. The concept is symbolized by the *Adibuddha*—the archetypal Buddha, the primordial image of all Buddhas. Each of the adibuddhas represents a unique aspect of personality or spirituality.

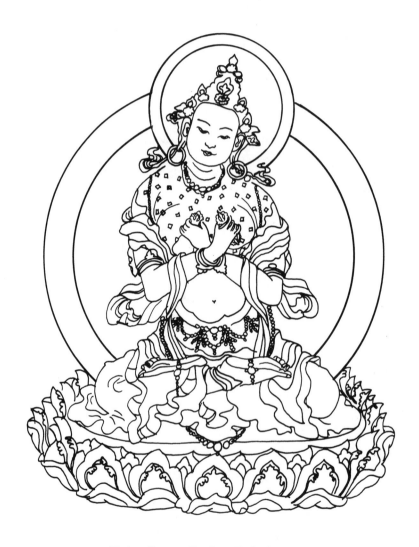

Vajradhara, Perfect Enlightenment

Vajradhara

Vajradhara embodies the ever-present Buddhahood in all that is alive, the potential in all beings to be free from samsara, the painful cycle of rebirth. Vajradhara represents the indestructibility and spiritually perfect, unchanging quality of this "one unknown, without beginning or end." Full initiates recognize this truth as the source of their divine inspiration and intuition, which is unknown to ordinary people.

Vajradhara is the symbolic father of all future Buddhas, having no beginning and no end. In his meditation, by exercising the five paths (dhyani in Tibetan), he created the five Dhyani Buddhas (the esoteric meditation Buddhas of the five colors found in the Tibetan Book of the Dead and other sources; see page 32). The teachings of this adibuddha date back to the fourth century; they reached their zenith with the introduction of the Kalachakra-system of teaching, in which the Buddha is portrayed as a kind of creator.

Vajradhara's skin color is blue, the color of infinite enlightenment. In his right hand, he holds the vajra (symbolizing method) and in his left, the bell (symbolizing wisdom). The two crossed over his chest symbolize non-duality and emptiness, the essence of Mahamudra—the Great Union—the basis and path of Buddhist teaching.

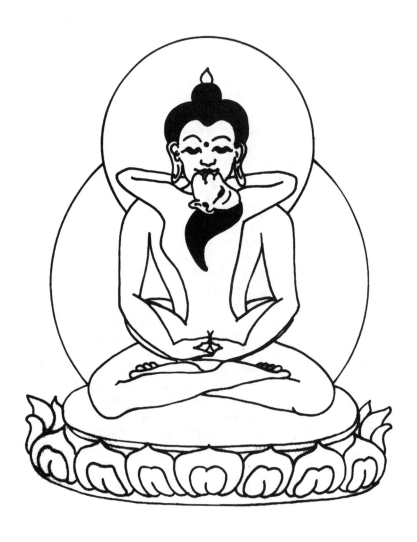

Samantabhadra, Goodness

Samantabhadra

Samantabhadra is goodness incarnate. Since he is entirely pure, he is depicted without clothing. He is usually seen in sexual union with Samantabhadri, his life companion, whose arms and legs embrace him. The similarity of their names points to the fact that both should be seen as one being, which again underscores the Tibetan Buddhist's belief that, in the final analysis, all beings are indistinguishable from one another because after reaching a karma-free existence, all beings are part of the One Absolute.

Samantabhadra depicted in sexual union is a symbol for the redemption of every being that has transcended karma, that is finally able to dissolve and become one with him. The more karma one bears, the further away he is from Samantabhadra and the more times he must go through the cycle of rebirth.

Samantabhadra in this position is often at the center of mandalas, representing the destination on the path to enlightenment.

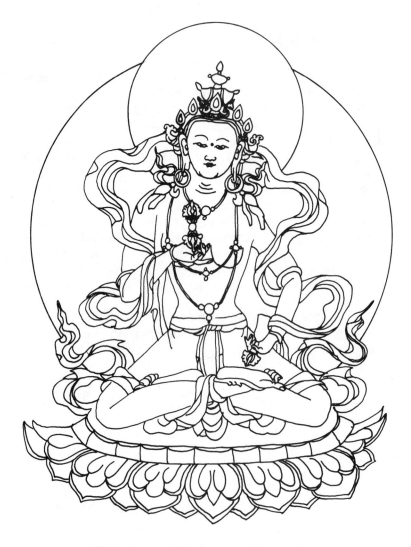

Vajrasattva, Wisdom and Empathy

Vajrasattva

In Tibetan Tantric Buddhism[2], *Vajrasattva* represents the principle of cleansing and purification of the spirit; he is the Buddha of Diamond Wisdom, and is the chief Buddha of the five Dhyani Buddhas. He symbolizes the ability to undo spiritual transgressions or contamination—as well as to fulfill neglected obligations toward one's teacher—by practicing purification.

Vajrasattva belongs to the Vajra Buddha Family (vajra in Sanskrit, *dorje* in Tibetan, meaning diamond or thunderbolt) and is connected to the Buddha Akshobhya (see page 37), which represents the perfection of ultimate truth that develops when the poison of hate is purified. Vajrasattva is paid special honor in yoga exercises where his 100-word mantra is used to aid spiritual purification.

His skin color is usually blue, the symbol of complete enlightenment. He sits on a lotus throne (see page 113) in the posture of vajrasana (see page 115), holding a vajra (diamond scepter) in his right hand in front of his chest and in his left, a bell. Together, they symbolize wisdom and goodness, the male and female principle, and spirit and pure light.

[2]*The main theme in Tantric Buddhism (Tibetan: Tantrayana; Sanskrit: Vajrayana, page 9) is the opposing energies of feminine and masculine. This duality, which also exists on the level of spirit and body, needs to be overcome. Once oneness is understood, enlightenment is taking place.*

The Five Celestial Buddhas

The five celestial buddhas (in Tibetan, Dhyani Buddhas), also known in Sanskrit as *Jinas* (eminent ones) or *Tathagatas*, differ from all other buddhas because they are timeless, always present, and independent of natural laws. They are assigned the five cardinal points: east, west, north, south, and center. In addition they are believed to be the guardians of a kind of pre-paradise.

The Dhyani Buddhas symbolize different aspects of enlightened consciousness and—while they differ for the purpose of meditation—in the final analysis they are the manifestation of perfect enlightenment. In Sanskrit, Tathagata means "one who has realized the Essence," which in Buddhism expresses the inexplicable transcendental spiritual reality of all things. In this sense, every object, every phenomenon, is not as it seems. A buddha is one who has transcended all earthly realities. Thus a buddha is able to guide and support all living beings in their attempts to connect with their own true natures.

The five celestial buddhas are also symbols for the purity of the five factors of existence (in Sanskrit, *Skandhas*: physical body, feeling, perception, impulse, and consciousness); the five elements (water, fire, earth, air, and ether); the five colors (green, blue, white, red, and yellow); the five points on the compass (as above) and directions of the wind; the five wisdoms (the similar, the essentially alike, the different, the complete, and the all-encompassing/transcendental); the five vices (zeal, anger/hate, selfishness, desire, and greed/miserliness); and the five Buddha Families (Conduct, Diamond, Wheel, Lotus, and Jewel).

Some Dhyani Buddhas are depicted with characteristic features, such as a protruding head or a curly lock of hair on the forehead; they may be adorned with royal jewels or a five-star crown. These differences signify their freedom from natural law as well as their independence of time and mortality. They may also carry some of the eight symbols of good luck (parasol, gold fish, lotus, wheel, urn, clockwise-spiraled conch shell, infinite knot, and victory flag, see page 123 ff.) or of the sun or moon (pages 88 and 89).

The Dhyani Buddhas are considered mere illustrations of the Adibuddhas; they can be perceived only spiritually and not by the senses. A tantric yogi (who meditates according to the rituals of Tibetan Buddhism) can perceive them during meditation.

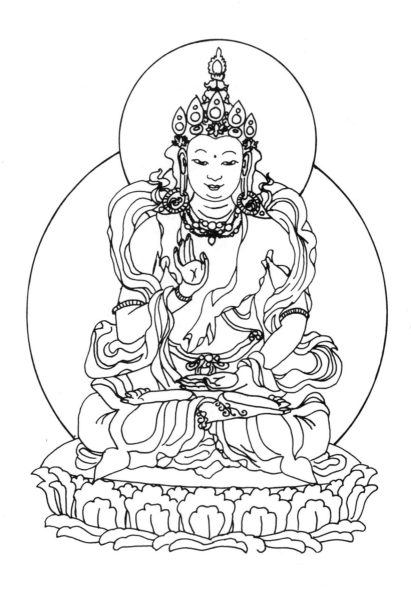

Amoghasiddhi, Fulfillment of All Goals

Amoghasiddhi

Amoghasiddhi is the earthly equivalent of the Buddha Maitreya (see page 17), as well as the transcendental Bodhisattva Vishvapani, or the Holder of the Double Vajra. He is known also as the All Powerful and the Unerring Achiever of the Goal. Amoghasiddhi represents perfect conduct where all greed and jealousy is transformed into sublime all-encompassing wisdom.

He usually holds his right hand in the Gesture of Fearlessness (abhaya mudra) and his left hand in the Gesture of Meditation (dhyana mudra). He bestows courage and protects in difficult situations. His identifying mark is the vajra cross (a double diamond scepter), sometimes held in his left hand. This cross symbolizes the practical application of all the wisdoms of the five celestial or transcendent Buddhas. He is the ruler of the Family of Conduct, his point on the compass is north, his element is air, and his animal is the eagle. When illustrated in color, his skin is green.

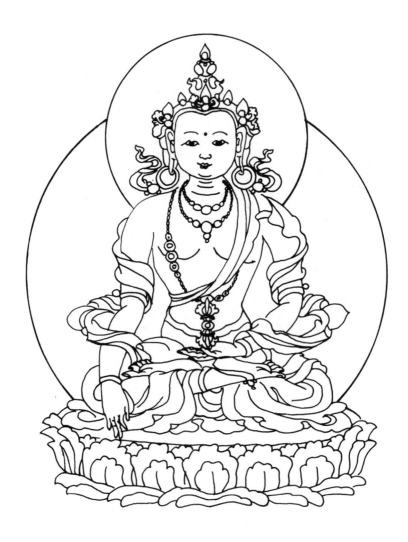

Akshobhya, Courage

Akshobhya

Akshobhya (meaning imperturbable in Sanskrit) is helpful in overcoming anger. Hate or rage is one of the greatest impediments to enlightenment and is therefore among the five vices or poisons (*jnana* in Sanskrit. The others are attachment, jealousy, pride, and ignorance). This Buddha can be helpful in transforming the vice of hate into wisdom.

Akshobhya is usually depicted sitting on a lotus throne with the right hand in the Gesture of Witness (bhumis-parsha mudra), also a symbol of perseverance. The left hand is resting with open palm in his lap. Sometimes the vajra scepter is held upright in the left hand, similar to bhumis-parsha mudra, reinforcing the idea of perseverance.

This Buddha is the ruler of the Diamond Family, he inhabits the Pure Land of the East, his element is water, and the animal associated with him is the elephant. When depicted in color, his skin is blue.

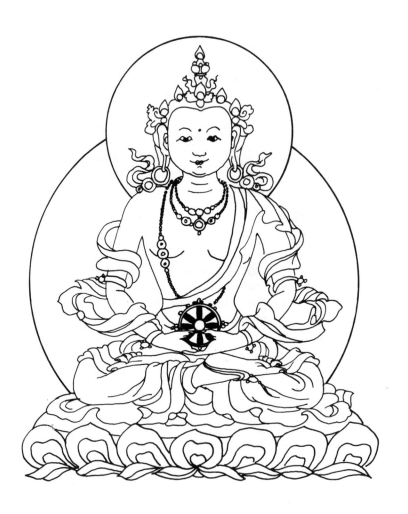

Vairocana, Transformation

Vairocana

Vairocana symbolizes the transformation from zeal and ignorance to all-encompassing wisdom. In Vairocana reside the combined qualities of the other four Dhyani Buddhas.

In a mandala, this celestial buddha is usually at the center. His hands are shown in the Gesture of Meditation (dhyana mudra) holding the wheel of dharma, signifying complete inner equilibrium. His symbols are the wheel (page 133) and the sun (page 88). On his head are a crown and the jewels of the Bodhisattva.

Vairocana is the ruler of the Buddha Family, his point on the compass is the center, and his element is ether. His skin is white in color. Sometimes he is depicted with four faces—one for each of the outward-pointing directions on the compass—signifying all-encompassing wisdom. The animals assigned to him are the dragon and the lion.

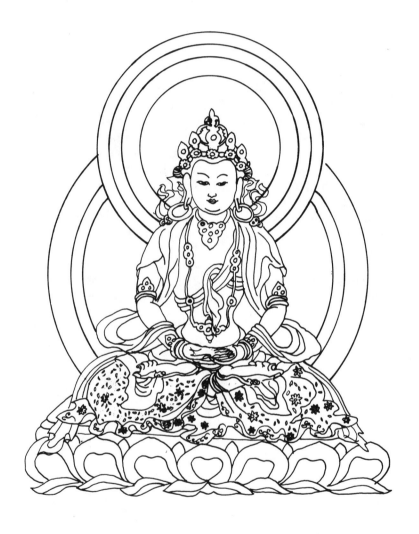

Amitabha, Infinite Light

Amitabha

Amitabha is the Buddha of Infinite Light. Historically, he is the oldest and most important of the five celestial Buddhas of the Mahayana. In the Schools of the Pure Land, in Chinese and Japanese Buddhism—in which he is known as Amida—he is much revered as the central focus of their teaching. These schools are known under the generic term Amidism. In contrast to the other celestial Buddhas, who are timeless and have always existed, Amitabha is said to have earned his place through karmic effort.

Amitabha symbolizes the transformation from greed to discriminating wisdom. He is depicted with his hands in the Gesture of Meditation, sometimes holding a begging bowl overflowing with fruit, a symbol of spiritual fertility. His symbol is the lotus flower, as he is the ruler of the Lotus Family. In addition he is the steward of the *Sukhavati* Paradise, where beings linger before they reach enlightenment and redemption. His skin color is red, reflecting his point on the compass—west. His element is fire and his animal is the peacock.

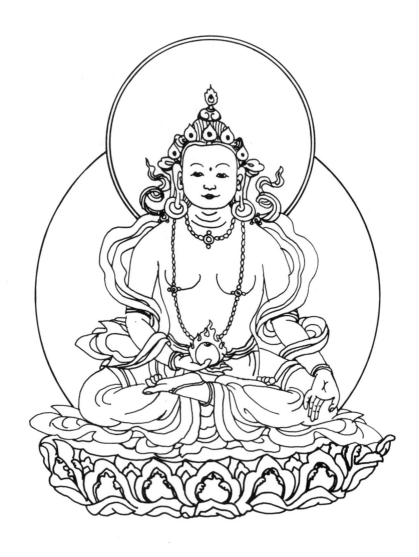

Ratnasambhava, Generosity

Ratnasambhava

The Buddha *Ratnasambhava* symbolizes the Wisdom of Symmetry, transforming greed into generosity, distributing favor, and supporting believers. His right hand is in the Gesture of Charity (varada mudra). His left hand holds the wish jewel (*cintamani* in Sanskrit, page 83), symbolizing the mind that has attained enlightenment; it enables him to provide help and fulfillment. Like the other Dhyani Buddhas, he wears sometimes the attire and jewelry of a bodhisattva and others, the garb of a simple monk. Ratnasambhava is the ruler of the Jewel Family, his point on the compass is south, his element earth. His skin color is usually yellow. His animal is the horse.

Bodhisattvas

In Sanskrit, bodhisattva means Enlightened Being or Enlightened Hero. A bodhisattva lives in the spirit of enlightenment for the betterment of all beings, in accordance with Vajrayana (Diamond Vehicle, page 9). The Buddha sends his essence in many different forms into the world where living beings are in need of help. The celestial bodhisattvas are *Avalokiteshvara*, *Manjushri*, *Tara*, *Vajrapani*, and Samantabhadra.

As followers of Mahayana (Greater Vehicle, page 9) understand it, a bodhisattva assists in releasing all beings from samsara. When one takes a vow to become a bodhisattva, he commits to putting the salvation of others before himself.

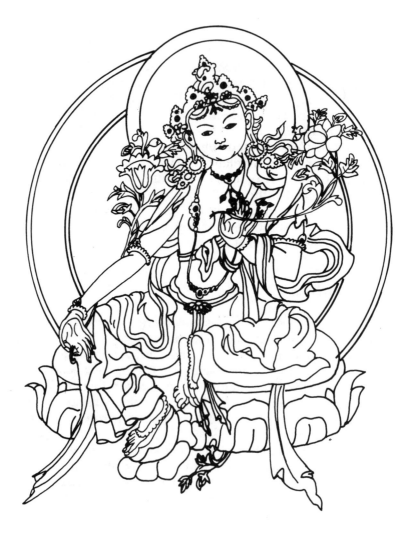

Green Tara, Removing of Obstacles

The path of Mahayana is divided into ten stages; at each stage, a particular virtue is developed, leading to freedom from samsara for all living things.

All bodhisattvas are exempt from natural laws, making them able to assume any and all forms and be in many places at once.

Green Tara

The Green Tara is the most dynamic emanation of the Tara. Her green skin color indicates her relationship to the family of the Amoghasiddhi, the Action Family.

She is a moderately combative, action-oriented bodhisattva, called upon when obstacles need to be overcome or when there is danger in overcoming evil. She is revered as a magnificent savior who frees all beings from suffering. She is seen as the Mother of All Three Periods—past, present, and future.

She is depicted sitting in a relaxed posture on a lotus throne, her right leg extended (indicating readiness for action) and her left leg in the meditation position. The relative positions of her legs symbolize her perfect wisdom, spirituality, and meditation technique. Her left hand holds the stem of a blue lotus flower in the Gesture of Holding a Triple Lotus. The flower is pointing above the left shoulder as a symbol of purity and power. Her right arm is extended, her hand in a gesture that (like the right leg) indicates the integration of wisdom and spiritual meditative technique. Another blue lotus, in full bloom, is raised above her right shoulder.

The youthful and beautiful Tara generates enthusiasm in those who adore her and gives them the courage to take action.

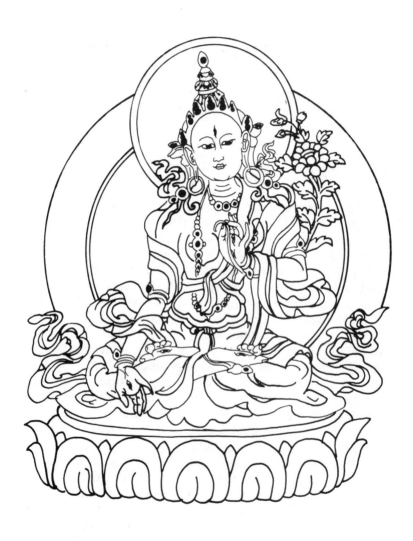

White Tara, Compassion and Protection

White Tara

The White Tara is a female bodhisattva who symbolizes compassion. Protecting those who revere her from danger, pain, and anxiety, she is the embodiment of motherly love.

Her right hand is held in the Gesture of Protection (abhaya mudra) and in her left hand, she holds a triple lotus flower. She has a third eye on her forehead and eyes on the palms of her hands and the soles of her feet; these eyes symbolize her capacity to know suffering in all regions of the world. She is the most revered Deity of Protection.

Both Taras, Green and White, sprang from a single tear of Avalokiteshvara, and they are considered his partners. The White Tara embodies his wisdom, the Green Tara his spontaneous willingness to help, born of his compassion for all living beings.

Altogether there are 21 forms of Tara, distinguished by their skin color, attributes, and body postures. The two Taras discussed here are the most well known.

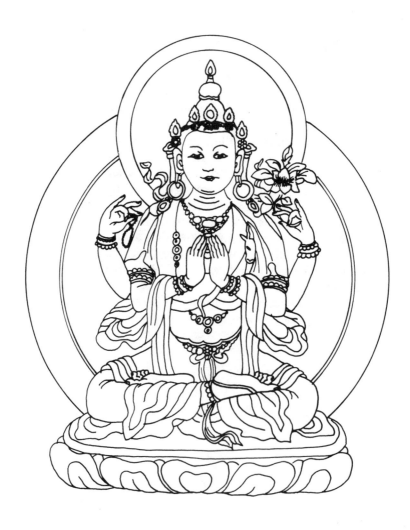

Avalokiteshvara, Infinite Compassion

Avalokiteshvara

Avalokiteshvara (in Tibetan, *Chenresi*) is the Buddha of Infinite Compassion and one of the most important bodhisattvas in Mahayana Buddhism. He is also called *Mahakaruna* (literally, Great Compassion, in Sanskrit), the Buddha embodiment of mercy. He is regarded as the bodhisattva manifestation of Amitabha, having the same boundless compassion. He is instantly available to all who call upon him with all their mind.

Avalokiteshvara appears in about 108 different forms. However, in the most well known, he has one face, four arms, and sits with his legs crossed on a lotus throne. On his head is a five-pointed crown; he often bears a small statue of the Buddha Amitabha (page 45) on his head as well. In his forward hands, he is holding the wish-fulfilling jewel, *Cintamani*, the symbol for all-encompassing compassion as demonstrated in the ability and willingness to help. In his right rear hand he holds the *Akshamala*, the prayer necklace or rosary (page 222) of Buddhism. The prayer necklace is used to aid concentration when starting to meditate and the beads are a means of counting the spoken mantras. In the left rear hand he holds a lotus flower as a symbol of spiritual development or unfolding (page 125).

The Dalai Lamas are thought to be incarnations of Avalokiteshvara and expressions of his divine concept.

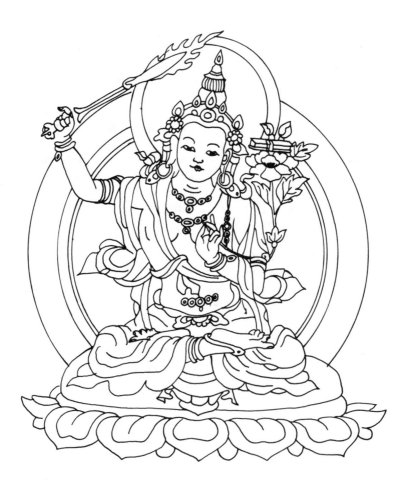

Manjushri, Dynamic Wisdom and Spiritual Knowledge

Manjushri

Manjushri, meaning Gentle Holy One, is the bodhisattva personifying dynamic wisdom and transcendental knowledge. Depicted as an eternally young prince, he reflects the Buddhist belief that wisdom does not relate to age or accumulated experience. In Buddhism, wisdom is the result of cultivating the spiritual capacity that is the guide to finding the true heart of reality.

His five-pointed crown symbolizes the Five Wisdoms of Enlightenment:

1) The wisdom of the Similar.
2) The wisdom of the Alike.
3) The wisdom of the Different.
4) The wisdom of the Complete.
5) The wisdom of the All-encompassing or Transcendental.

In his right hand he holds a flaming double-edged sword that cuts through ignorance and brings wisdom, the ability to discriminate. In his left hand he holds a lotus flower on which rests the book of the Prajnaparamita sutra, a compilation of Buddhist literature that goes back some 2,000 years.

Like many bodhisattvas, Manjushri takes a number of different forms. As Caturbhuja for instance, he has four arms. In addition to the sword and the book, he holds a bow and arrow, which signify his verbal as well as his philosophical accuracy.

As Namasangiti, he has twelve hands, which he holds above his head. This more rare gesture depicts the height of enlightenment.

Divinities

Wrathful Gods

Wrathful or angry gods are somewhat paradoxical embodiments of enlightened beings, as they simultaneously represent the antithesis—a world torn apart by contradictions. Even their anger can be helpful, if unpleasant, for those who seek enlightenment, or who have not yet started on the path.

These Buddhas are distinguished foremost by the flames around their heads. They also bear a scornful expression or a grimace, with protruding eyeballs and a mouth wide open, exposing their tongues and teeth.

They are usually heavyset with bloated stomachs and may appear distorted and almost gnome-like. They wear gold wristbands and, often, loincloths made from elephant skin. These gods wear necklaces and belts decorated with skulls and the rings around their ankles often look like snakes.

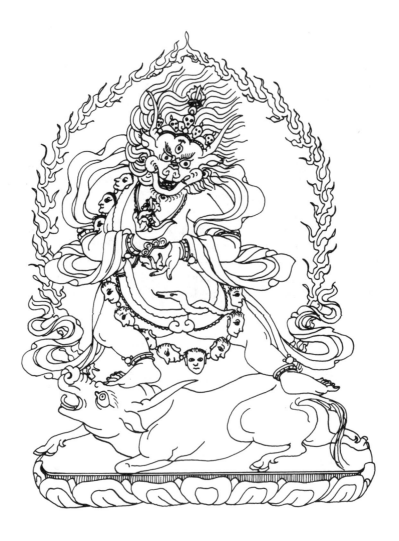

Conqueror of Death

Yamantaka

Yamantaka, also known as the Conqueror of Death, is one of the most fearsome *Dharmapalas*, the wrathful gods. He is the equivalent of the diamond wisdom of the highest reality and can defeat evil, sorrow, and death. He is the wrathful side of Manjushri and of the Conqueror of the God of Death, *Yama*, who rules over the mythological hell of Buddhism. He is the god of protection of the *Gelug* School (one of the four main schools of Tibetan Buddhism, founded by Tsongkhapa, page 205).

There are many different and symbolically rich depictions of Yamantaka. His skin may be blue, red, black, yellow, or white. His face usually has the shape of a buffalo's. On the sides of his face may appear the faces of human beings. He is often depicted in a fearsome or threatening form as Vajrabhairava with nine heads. The number of his arms varies between two and twenty four and of his legs, between two and sixteen. He may sometimes stand atop an animal or demon. His signature is a hatchet (see page 197) and the top of a skull (see page 226). He wears the jewelry of the wrathful gods—a necklace of disembodied heads and a crown bearing five skulls, earned by transforming the Five Vices.

The figure of Yamantaka is related to transformed wisdom that conquers mortality, fear of death, and fear of the unknown. Each of his individual symbols—head, crown, frame, adornment, and bodily features—is an aid on the path to enlightenment.

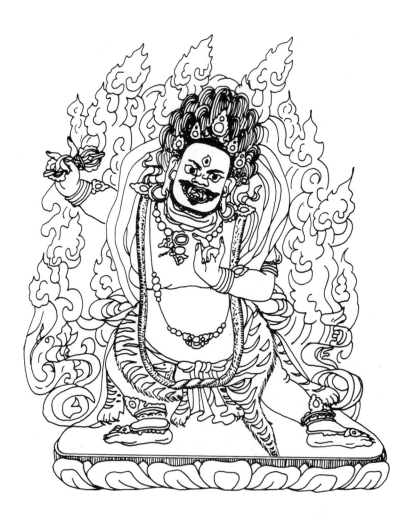

Vajrapani, Unimaginable Strength

Vajrapani

Vajrapani is the wrathful god who embodies unimaginable strength. He symbolizes the unyielding effectiveness of Buddhist practice to conquer negativity. Vajrapani symbolizes the strength and energy of enlightenment, which is why he is depicted in such forceful, active posture. In addition, he is the guardian of secrets and mysteries, the one who fights against the power of blindness and ignorance.

His skin color is blue and the tiger-skin belt that he wears around his hips signifies virility. His hands are held in the Gesture of Threatening and Warning. In his right hand is the Vajra (diamond scepter). Snakes are symbolic of the power of the unconscious and the snakes with which he is decorated are meant to control his anger. He is sometimes depicted with six or eight legs, standing on a human being or a demon. He can be identified by the Vajra, a bell, a lasso, a Kapala, and a sword (see ritual icons, page 221).

Vajrapani, Avalokiteshvara, and Manjushri form a trinity that stands collectively for strength, mercy, and speech, as well as wisdom and spirit. They are models of good action, speech, and thinking, because behavior, language, and thought make it possible to feel at one with Buddha and with Absolute Reality. Whenever three *stupas* (see page 180) appear together in the colors blue, white, and yellow, they symbolize the trinity of these three bodhisattvas. Blue stands for Vajrapani, white for Avalokiteshvara, and yellow for Manjushri.

Lesser Deities

The four *Lokapalas* (Tibetan), also known as shepherd kings of the four cardinal directions (East, West, North, and South), are considered lesser deities. They are the guardians and kings of the four worlds. In Buddhist mythology, the mountain *Meru* is considered the center of the universe, surrounded by four worlds. The Southernmost world is the one closest to us.

The Lokapalas were already mentioned in early Buddhist writings in connection with the life of the Buddha Shakyamuni. Each is mentioned in the most important stages of the Buddha's life.

In Tibetan Buddhism they are often depicted at the gates of cloisters or painted on the walls at the entry to gathering halls. They are always seen as a group with the exception of *Vaisravana*, who by himself is honored as the god of prosperity. They are often seen standing or sitting on serpents. They usually wear armor and helmets or crowns.

Their job is to protect the Buddha from worldly dangers and to report to the gods on how diligently human beings are trying to reach enlightenment. In addition, they protect the world from demons entering the place of the Buddhas.

Dhrita-Rashtra

Dhrita-Rashtra is the white guardian of the East. He can be recognized by the lute, a symbol of mortality. He is also known as the King of the Incense-Devouring Demons.

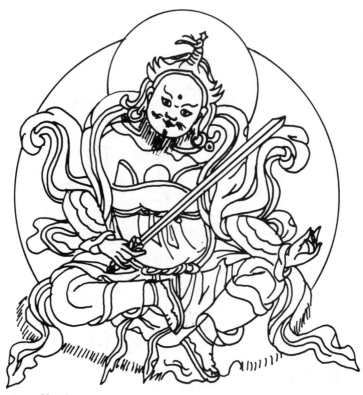

Virudhaka

Virudhaka is the guardian of the South. His skin color is green or blue. He can be recognized by the sword (page 199) he holds in his right hand. He is also known as the King of the Monster Demons.

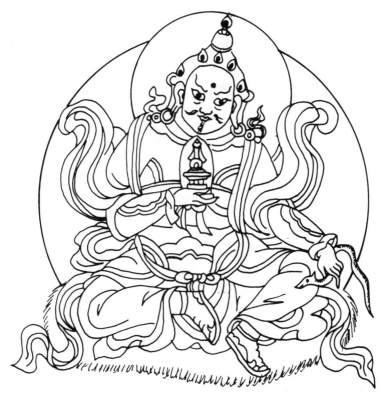

Virupaksha

Virupaksha is the guardian of the West and his skin color is red, reflecting the setting sun. He can be recognized by the stupa (page 180) and the serpent (page 167). He is also known as the King of the Serpents.

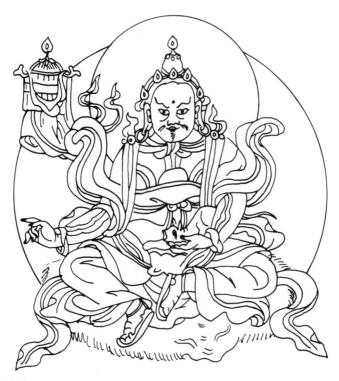

Vaisravana

Vaisravana is the guardian of the North and his skin color is yellow. He is identified by the jewel-spewing *nakula* (mongoose, page 169) and the victory banner (page 135). He is also known as the King of Illness-Spreading Yaks (Indian ghosts of the forest or wilds, or elfish demons).

Primary
Symbols

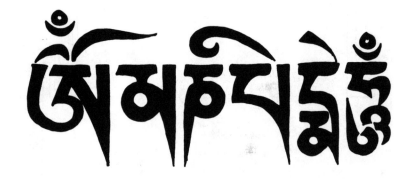

The Jewel in the Heart of the Lotus

The Mantra OM MANI PADME HUM

The word mantra in Sanskrit means something like spirit protection. It is a group of sacred syllables and sounds that holds the essence of a sacred being and is able to make that being available to the religious adherent who speaks it. In addition, a mantra represents the essence of creation, the primordial sound that gives form to the relativity of existence.

A mantra contains one or more syllables that are continuously repeated during meditation. Each syllable represents an aspect of the cosmic energies of a Buddha. The recitation of a mantra by the meditator expresses his or her belief in the redeeming power of the spoken word. Recitation is done in a specific rhythm.

One of the best known and most often used mantras is that of Avalokiteshvara, the Buddha of Compassion, "om mani padme hum." Neither the first nor the last syllable is translatable but the middle part is often translated as the "jewel in the lotus." Its sound is supposed to ring throughout the universe, telling of the victorious power of freedom that is to save all beings.

The syllable "om" stands for body, spirit, and speech of the Buddha, "mani" for the path of teaching, "padme" for the wisdom of the path, and "hum" points to the union of wisdom and the path to it.

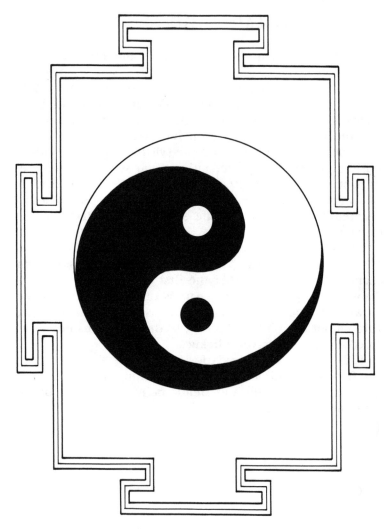

Polarity and Resolution

Yin and Yang

Yin and Yang, shaped like spiraled tear drops or paisleys, constitute a circle that is divided in two by an S. The dot in the middle of each half symbolizes that each element at its highest point carries within itself the seed of its polar opposite, that it can change and cross over into the other.

Yin is the female, the passive, the receptive, the dark, and the soft. Yang is the masculine, the active, the light, and the stern. The joining of the two created from the One is the source of creative energy in the Universe.

In many depictions, the Yin and the Yang are surrounded by the I Ching diagram. In this case, they signify heaven, earth, fire, water, wind, thunder, and mountains.

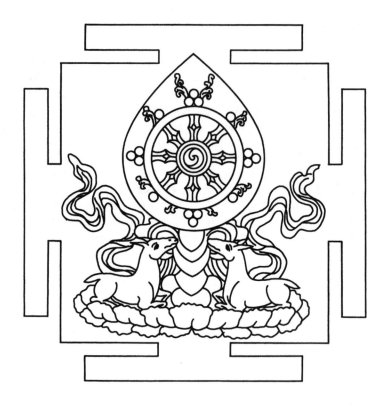

The Wheel of Buddhist Teaching

Dharma Wheel with Gazelles

The dharma wheel represents the whole canon of Buddhist teachings. It has three central elements:

The Four Noble Truths:
 The truth about suffering.
 The truth about the origin of suffering.
 The truth about the cessation of suffering.
 The truth about the path.

The Eight-fold Path to the release from samsara and the beginning of nirvana includes: right understanding, right intention, right speech, right discipline, right livelihood, right effort, right mindfulness, and right concentration.

The Middle Way, that path which is taught by the Buddha, avoiding extremes, also known as the Golden Middle.

The dharma wheel usually has eight spokes, signifying the eight-fold path. The two gazelles sitting under the dharma wheel are supposed to have been the first witnesses to the Buddha's preaching.

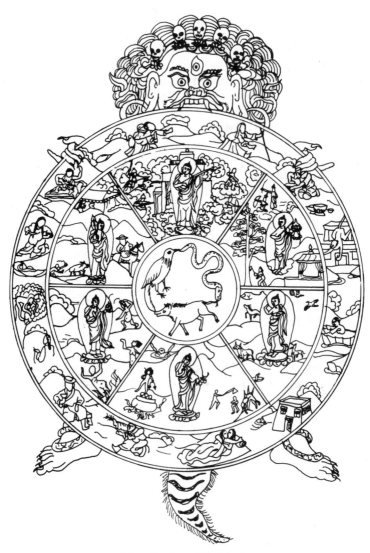

The Cycle of Rebirth

The Wheel of Life

The wheel of life depicts all the areas of existence into which a being can be reborn. There are three lower areas in the bottom half of the wheel. In the lowest (below, center) is that of the hell-ghosts, whose chief characteristic is hatred. Even from this lowest level, beings are still able to reach enlightenment. Here on the wheel of life, Buddha is seen with a flame in his hands, symbolizing the redemption of the hell-dwellers.

The adjacent area (below, left) is that of the beings who hunger. Their basic trait is greed. They have the distended bellies of extreme hunger and skinny necks that keep them from swallowing the food they need. The Buddha appears here with a bowl filled with amrita, the food of the gods and proof of his generosity. It symbolizes Buddha's generosity in helping the hunger-ghosts to overcome their greed.

The third area (below, right) is that of the animals. They are governed totally by their drives and instincts, entirely lacking in the comprehension of real freedom. And this is their main shortcoming: their lack of consciousness. In this area the Buddha appears holding a book, indicating that he wants to help the animals learn the power of conscious thought.

The upper half of the wheel features the elevated areas of being. First is the world of human beings

(above, left), the lowest of the three elevated areas. The greatest shortcomings of human beings are their failure to understand the meaning of life and their tendency to ignore the many possibilities available to them. The Buddha appears here with a walking stick, symbolizing the urgent necessity for each individual to commence his or her spiritual journey.

Above the area of humans (above, right) is that of the Asuras, the so-called anti-gods. Though very wealthy, they are nonetheless jealous of the knowledge possessed by the gods above them. To free them from their jealousy, the Buddha carries a canopy, the symbol of wisdom. He thus attempts to teach the Asuras that right striving is for wisdom and not fortune.

The center area at the top of the wheel is that of the gods; these beings have reached pure happiness but have still to achieve enlightenment. Their pride blinds them to the fact that happiness and good luck are only temporary. Here the Buddha carries a lute, symbolic of the transitory nature of happiness and luck: they are as ephemeral as the sound of a lute.

The circle at the wheel's center features the three vices—greed, hate, and ignorance—depicted by three animals. The snake represents hate, the bird symbolizes greed or desire, and the pig denotes ignorance.

The wheel's outer rim shows the twelve aspects of interdependent evolution. The first six are ignorance, action, consciousness, name, body, and birth and death.

The remaining six are the senses, those of touch, emotion, desire, grasping, becoming, and aging.

The whole structure is held up by Yama, the god of death, who lends his unimaginable strength to the fight against blindness and ignorance.

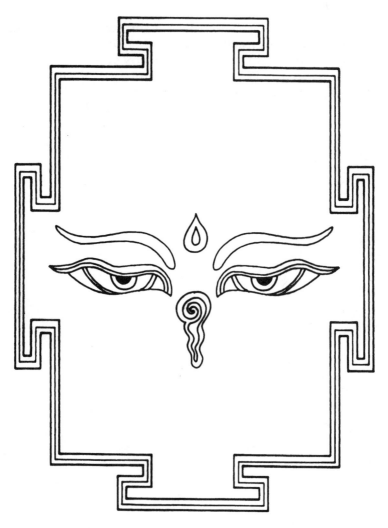

The All-Seeing Eyes of the Buddha

The Eyes of the Buddha

The drawing (left) represents the all-seeing eyes of the Buddha. The nose is in the shape of the number one in the Newar language, that of a tribe in Nepal. This sign often appears on all four sides of stupas (page 180) in Nepal. The eyes belong to the Adibuddha—also known as the Meditating One—who peers in all directions from inside the stupa.

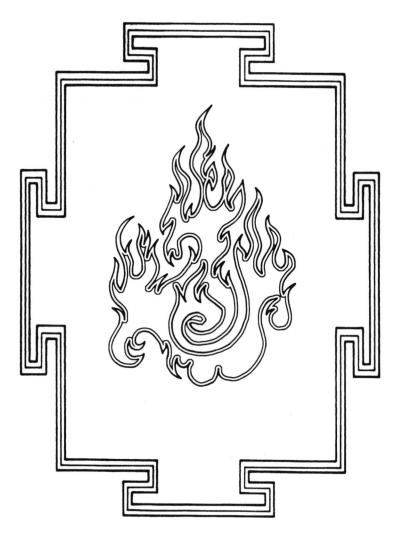

Highest Consciousness

The Wreath of Flames

Agni

The fire mountain or fire wreath is often depicted in the colors of the rainbow: green, blue, white, red, and yellow. He is the symbol of the highest consciousness.

A fire wreath in a mandala is supposed to burn away ignorance and with its light drive out darkness for the person who is meditating. In this way he is opening the path to transcendental, spiritual wisdom.

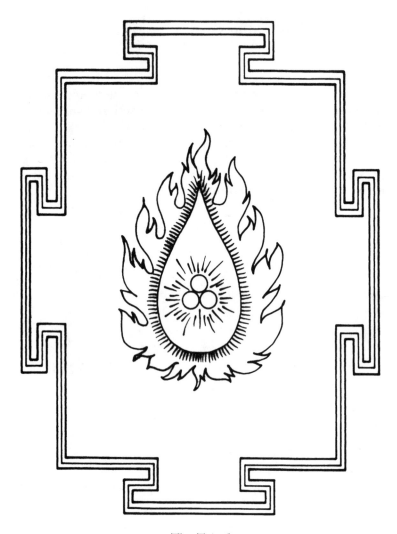

The Triad

Triratna

Triratna in Sanskrit means Three Bodies or Triad. It represents the state of buddhahood, an inexpressible, unimaginable reality that lies beyond all thinking or conceptualizing. The three circles represent the bodies of truth, pleasure, and appearance. The term "body" refers not to the physical body, but to the highest development of spirit, speech, and body.

Triratna refers also to the three jewels of Buddhism: Buddha himself (the Enlightened One), dharma (his teachings), and *sangha* (a community of monks). They are depicted, as on the opposite page, surrounded by flames.

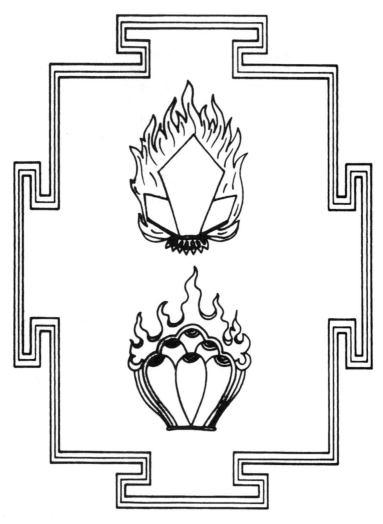

The Jewel of Desire

The Jewel of Desire

Cintamani

The Cintamani (Sanskrit) is a magical jewel with the power to grant wishes. It is able to fulfill any and all desires. It is also called the Thinking Jewel.

Generally speaking, a jewel in Buddhism symbolizes the importance of teaching. Cintamani also represents the mind that has attained enlightenment. Cintamani can appear as a simple jewel (as above) or in a more spherical shape ringed by flames (as below). Sometimes Cintamani is also depicted in the shape of a pearl.

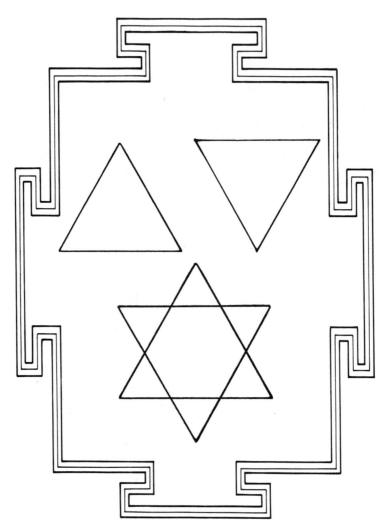

The Masculine and Feminine Principles

Trikona

The triangle pointing down symbolizes the feminine and, pointing up, the masculine principle. The triangles superimposed form a six-pointed star, representing the union of the masculine and feminine principles. This is the symbol for the dissolution of all duality.

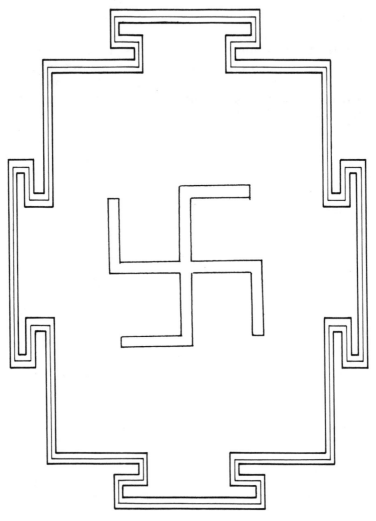

Happiness, Unshakable Concentration, and Stability

The Cross of Happiness

Swastika

A swastika pointing to the right is a Buddhist symbol for the teaching (dharma) of Gautama Buddha. A swastika pointing to the left is a remnant of the early Tibetan Bon religion.

The word swastika comes from Sanskrit and means good luck or well-being. This ancient symbol also stands for stability and unshakable concentration.

Surya

Surya is the Sanskrit word for sun; it represents the masculine principle. When paired with the moon, representing the feminine principle, it symbolizes the removal of polarity.

Chandra

A quarter or partial moon and a full moon are symbols of the feminine principle. One or the other often appears together with the sun, a symbol for the masculine principle. Both symbols are often pictured in the sky on a *thangka* (see page 191).

Renewing Energy

Water

Water is a common offering, like light (page 223), presented in one of the eight offering bowls during a Buddhist ritual. It represents the feminine and the renewing of the energy of the Universe. It is closely related to the moon. For some deities, the water will be purified with certain herbs before being offered.

It is also an aid to meditation. In Zen Buddhism, a calm lake is a symbol for the cleansing and calming effects of meditation. The initiate experiences several stages of consciousness before reaching a true understanding of the spirit of water.

Mudras and Asanas

Mudras

Mudra is a Sanskrit word meaning sign or seal. In Buddhism, it is a sacred hand gesture expressing inner wisdom.

A mudra is a symbolic position of one or both hands signifying a certain energy or action. Mudras appear frequently in Buddhist art. In fact, these hand positions are often the only way by which one Buddha can be recognized or distinguished from another. Mudras are also an aid to meditation. A mudra may be associated with a certain mantra or visualization and so may help maintain focus while meditating.

Buddhist icons generally feature one of six mudras: that of enlightenment, meditation, argument, mercy, warding off evil, or praying. Buddhas with their hands in any of these mudras are usually sitting in a lotus position (page 114).

Asanas

In Sanskrit, *asana* means body posture. These are ritual body positions, serving a function similar to mudras in conveying an energy or attitude. A subgroup of asanas are *sthanas*, or standing postures.

The place where a figure in a picture is sitting is also called asana.

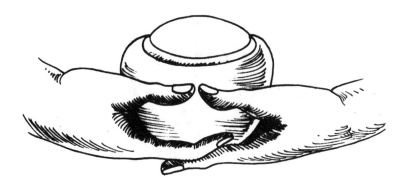

Dhunana

Gesture of Inner Balance

The *Dhunana* mudra is a basic position signifying the Gesture of Absolute Balance during meditation. The hands are held palms up, relaxed in the person's lap, with thumbs and fingers touching. The person meditating is completely indifferent to the world around him or her, unaware of his surroundings, totally immersed in boundless space.

This posture symbolizes a state in which objective consciousness is removed. This gesture was assumed by the Buddha as he sat under a fig tree where he submerged himself in meditation. The gesture helped him reach a state of deep reflection.

When seen together with the meditation bowl (as shown in the drawing, page 231), this gesture is a sign that the figure depicted is the abbot or abbess of an order.

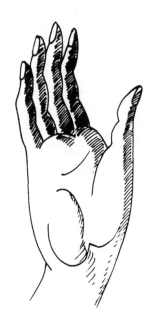

Abhaya

Gesture of Comforting and Fearlessness

The Abhaya mudra is a gesture of comfort, blessing, and protection, as well a gesture of encouragement and fearlessness. The Buddha's hands assumed this gesture after he reached enlightenment, signifying don't be afraid.

The fingers of the hand are extended and pointing up, with the palm facing away.

Dharmachakra

The Gesture of Teaching

The gesture of teaching, also called the Gesture of the Preacher, symbolizes setting the wheel in motion. It recognizes the moment when Buddha sets moving the wheel of instruction that leads to enlightenment. At that moment, his students begin to follow the path not only to knowledge, but to healing.

In this gesture both hands are used; they are held in front of the heart. The thumbs and index fingers of both hands form a circle, the palm of the left hand facing the body and the right palm facing away.

Bhumisparsha

Gesture of Witness or Touching the Earth

Gautama Buddha used the Bhumisparsha gesture to summon the earth goddess, Sthavara, as witness to his attainment of Buddhahood. The gesture signifies the state of enlightenment reached by the Buddha after meditating under the bodhi tree for four weeks and withstanding all the temptation put before him by *Mara*, the god of evil.

It is made using both hands. The right hand rests on the right knee, palm inward, the fingers extending to touch the ground. The left hand rests in the lap, with the palm up.

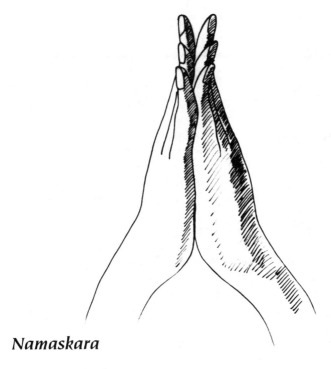

Namaskara

The Gesture of Prayer

Namaskara, also called *Anjali*, represents greeting, prayer, and worship. Regarded also as a sign of respect, it is never seen on Buddhas or Bodhisattvas.

In this attitude, the hands are held palms together, fingers touching, in front of the heart. This gesture also expresses the state of being. This mudra is similar to the Western image of hands in prayer.

Vitarka

Gesture of Argument or Debate

The Vitarka mudra is a symbol for intellectual discussion or debate. The circle formed by thumb and index finger symbolizes the Wheel of Teaching (dharma).

Though this is primarily a gesture of the Buddha Amitabha (page 41), in general, it identifies the Buddha as a teacher. It emphasizes the message he imparts. Gautama Buddha discovered the power of his teaching in his travels, as it deeply impressed his students. He valued intelligent argument for its ability to convey seemingly inexpressible concepts.

With the hand pointing to the ground, this gesture symbolizes the integration of wisdom and intellectual technique.

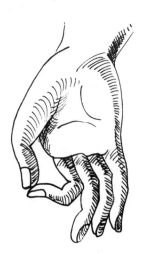

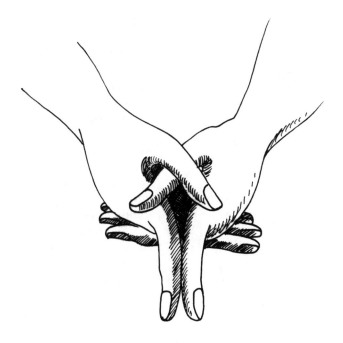

Ksepana

The Gesture of Nectar Sprinkling

Ksepana, also known as the Sprinkling of Ambrosia (amrita) mudra, is used when the sprinkling of nectar is intended to convey immortality. The hands are held at waist height, palm to palm, with index fingers together and extended, pointing downward at a vase or container.

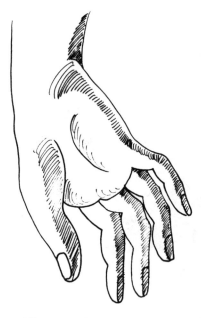

Varada

Gesture of Charity

This gesture, in which the right hand extends downward with the palm facing away, symbolizes Shakyamuni summoning Heaven as witness to his enlightenment. It symbolizes the gift of truth that the Buddha offered to the world. Though he severed all emotional ties to the world, he remained connected to it by his vow to save others from the "river" of suffering.

This is why this mudra is also called the Gesture of Mercy. During the development of Mahayana Buddhism (Greater Vehicle, page 9), the central role of mercy and compassion as part of the teachings of the historical Buddha reached its full expression.

This mudra is most often associated with the Standing Buddha and is frequently combined with the abhaya mudra. It is sometimes seen with the left hand instead of the right.

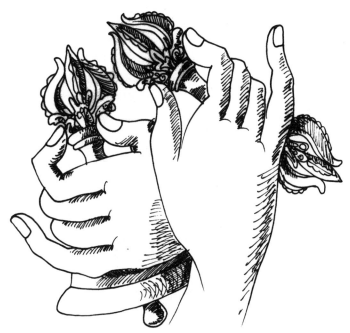

Vajrahumkara

Gesture of Union or HUM

In this gesture, also known as the embracing mudra, the bell (*ghanta* in Sanskrit, *drilbu* in Tibetan) is always held in the left hand; it symbolizes wisdom, sunyata, nirvana. The right hand always holds the vajra (diamond scepter, dorje in Tibetan), symbolizing skilful means, compassion, samsara. The hands or arms are crossed, signifying the union of both: the path and the goal are one. In the mantra om mani padme hum, the final syllable is a verbal symbol for this concept. This mudra is typical of the Adibuddha (page 25).

103

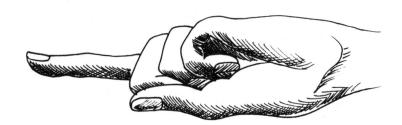

Tarjani

Gesture Warding Off Evil

This is a gesture of anger or menace in which the hand forms a fist, with forefinger and (sometimes the) little finger outstretched toward the opponent. *Tarjani* mudra is a warning gesture associated with wrathful deities.

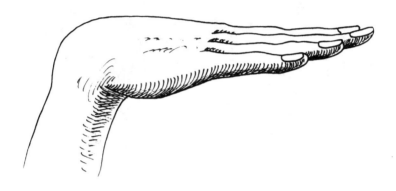

Tarpana

The Paying of Homage Gesture

The *Tarpana* mudra symbolizes paying homage where only one hand is used. The hand is held pointing forward at shoulder height with the palm facing down. This gesture is most often used by Manjushri, especially in the form of Namasangiti (see page 51).

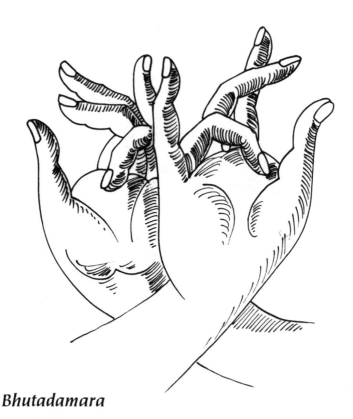

Bhutadamara

Gesture of Reverence

This gesture is a sign of reverence, but is also known as the Warding Off Evil or Awe-Inspiring mudra. The wrists are crossed in front of the chest (the right hand over the left, palms turned out). The hands are always empty.

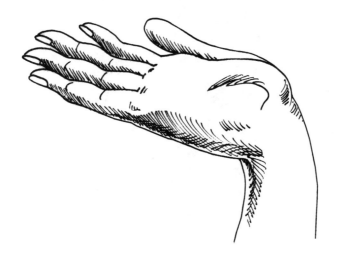

Buddhashramana

The Gesture Beyond Misery

Buddhashramana mudra is also called an Ascetic's Gesture
of Renunciation. The right hand is bent at the wrist, palm
up, fingers extended.

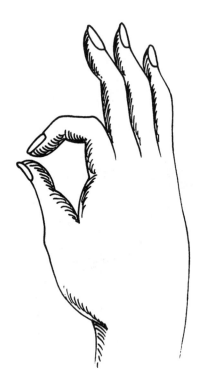

Jnana

Gesture of Instruction

The Buddha is often depicted with this mudra, indicating that a pronouncement is being made or instructions given. It is also called the Sign of Insight. The hand is held palm in, with the thumb touching the tip of the middle or index finger, forming a circle. This signifies embracing knowledge of the three worlds and improves concentration.

108

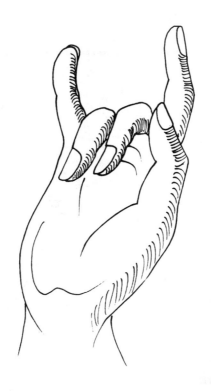

Karam

Gesture of Banishing

This mudra is used to banish demons.

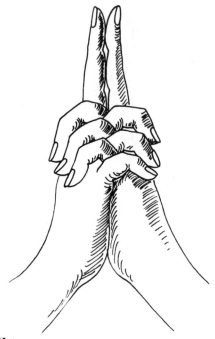

Uttarabodhi

Gesture of Perfection

This mudra is called the Gesture of Highest Enlightenment.
The hands are held close to the breast, the index fingers
extended and touching, and the rest of the fingers crossed.
This mudra is frequently seen in images of Vairocana.

110

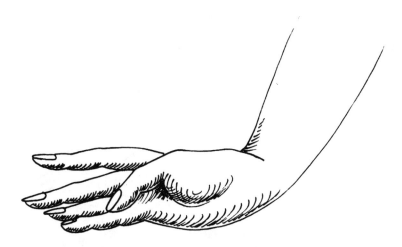

Sramana

Gesture of Abdication or of the Ascetic

Sramana (Sanskrit, meaning one who practices austerities) is the mudra of abdication, the relinquishing of all worldly pleasures. The hand is held away from the body and bent at the wrist, palm down, fingers extended.

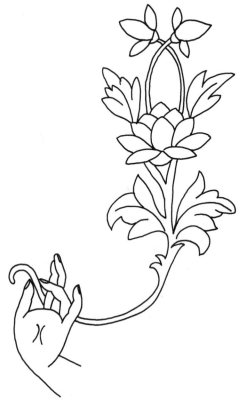

Triple Lotus Flower

Here the thumb and index finger of one hand hold a lotus flower at the stem. Its bud, bloom, and closed flowers symbolize the Buddhas of past, present, and future.

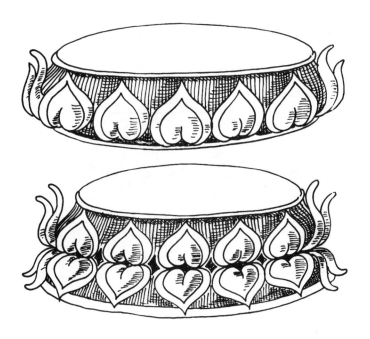

Lotus Throne

The lotus throne may have either a single wreath of blossoms (above) or a double (below). The flowers may appear in color. The lotus flower is the symbol of purity of mind and of the earth (pages 125, 171).

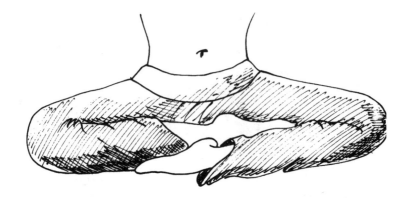

Padmasana

Lotus Position

This is the *Padmasana* (from the Sanskrit *padma*, meaning lotus, and asana, meaning to sit quietly), the Lotus Position familiar to students of yoga. In Padmasana, the feet can take any of a number of different positions. Here, the feet are crossed in the meditation position.

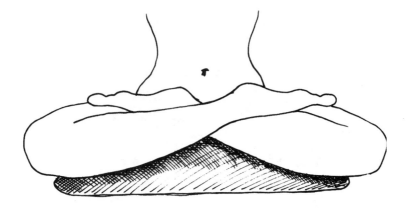

Vajrasana

Diamond Position

The *Vajrasana* is also known as the Diamond Position. In contrast to the Padmasana, where the feet are in front, the feet here rest on the thighs. The Buddha Shakyamuni—as he sat under the Bodhi tree—assumed this position on the last day before his enlightenment.

Maharajalilasana/Lalitasana

King's Posture/Sporting Posture

The image above combines two asanas: *Maharajalilasana* (King's Posture or Royal Ease), in which one leg is folded vertically against the body and the other leg is folded horizontally on the ground; and *Lalitasana* (Sporting Posture), in which one leg is folded in horizontally toward the body and the other leg hangs over the edge of the "seat" or "throne." Both postures convey relaxation and composure.

Bhadrasana

Benevolent Posture

In contrast to many Buddhist icons, where the figure is posed in meditation, Maitreya is often depicted in *Bhadrasana*. The figure appears to sit comfortably with his feet resting on the ground in European or Western style. The posture seems to suggest that the throne on which he sits is not really his own, but is on loan. Or it may convey his readiness to get up and go out into the world for the benefit of all living things.

Tribhanga

Triple Bend

The starting point for all standing postures (sthana) is *Samabhanga*, in which both feet carry the weight of the body equally.

In the case of *Tribhanga*, also known as the Triple Bow, the weight is shifted to one leg and the other (active leg) is slightly to the front or side. The torso, hips, and legs are all orientated in different directions, giving the body the three curves of an "S" shape. The pose may derive from ritual dances.

118

Chapasthana

Bow Position

This sthana is called the Bow Posture. It is a symbol for flying. The leg bent at the knee and pulled into the body represents the bow, the other slightly bent leg represents the arrow. *Chapasthana* is most often seen in gods depicted in dancing positions.

119

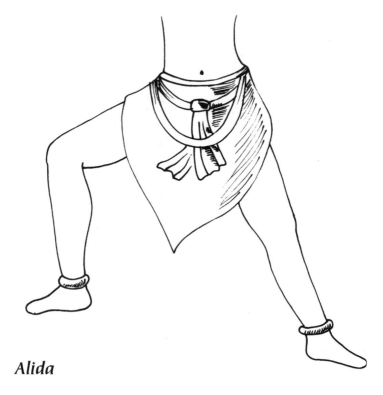

Alida

Powerful Kick

This posture is characteristic of a wrathful god, *Dharmapala*. Either the left leg (Sanskrit, *alida*) or the right (Sanskrit, *pratyalida*) steps forcefully to the side.

Symbols of
Good Fortune

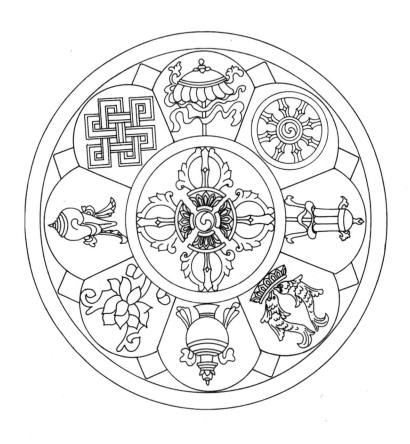

*Parasol, Wheel, Flag or Standard, Golden Fish, Urn,
Lotus Flower, Conch Shell, and Infinite Knot
(clockwise, starting at 12 o'clock)*

The Eight Auspicious Signs

Symbols of good fortune were long ago established in ancient Indian religions, and Buddhism has many of its own, including things from graphic designs to plants and animals. In Tibetan Buddhism, one group of eight symbols is the oldest and best known, with roots that can be traced back to canonical texts.

These eight symbols are the parasol (Sanskrit, *chattra*), the golden fish (Sanskrit, *survanamatsya*), the urn (Sanskrit, *kalasa*), the lotus flower (Sanskrit, padma), the clockwise-spiraled conch shell (Sanskrit, *daksinavartasankha*), the infinite knot (Sanskrit, *srivatsa*), the flag or standard (Sanskrit, *dhvaja*), and the wheel (Sanskrit, chakra).

Purity of Spirit

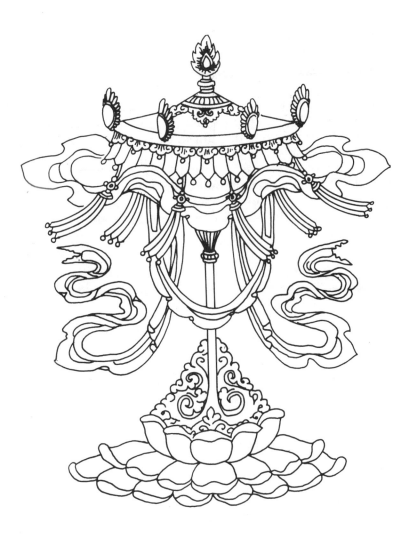

The Lotus Flower

(Sanskrit, Padma)

The lotus flower symbolizes purity of mind or divine creation; the latter is particularly true for the open lotus flower. From the muck of a pond, where the roots of the lotus reside, springs forth an immaculate white flower to rest on the surface of the water as an example of the harmonious unfolding of spirituality.

The lotus flower is also a symbol of earth. Tibetan Buddhist mystics imagined the earth floating like a lotus flower on the oceans of the universe. The heart of the flower is the cosmic mountain, the axis of the Universe.

While the lotus flower is not represented in all Buddhist traditions as it is in Tibetan Buddhism, it remains, in general—usually in stylized form—one of the primary symbols of Buddhism.

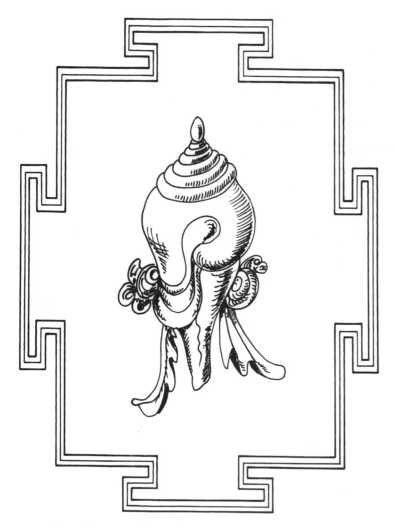

Proclaimer of the Glory of Buddhist Teaching

The Conch Shell

(Sanskrit, Daksinavartasankha)

The clockwise-spiraled conch shell (daksinavartasankha, pages 141, 155, 215) represents the glory of the teachings of Buddha. Its sound is thought to carry the enlightenment of the Buddha into every corner of the world.

Created by nature and not by human hands, it is one of the oldest ritual objects in Buddhism. It is not called by the same name everywhere. Sometimes it is referred to as a snail shell, sometimes as a conch shell. The Tibetan name *dun* means both.

The Parasol

(Sanskrit, Chattra)

The parasol or canopy (chattra) has been a luxury item and a symbol of power in India for thousands of years. In religious terms, it provides protection from defilement by the spiritual poisons of desire, hate, greed, and ignorance. A silk parasol protects the head of Buddha and serves as a symbol of spiritual power.

Important religious leaders had the right to carry such a parasol. Secular rulers could carry a parasol decorated with peacock feathers.

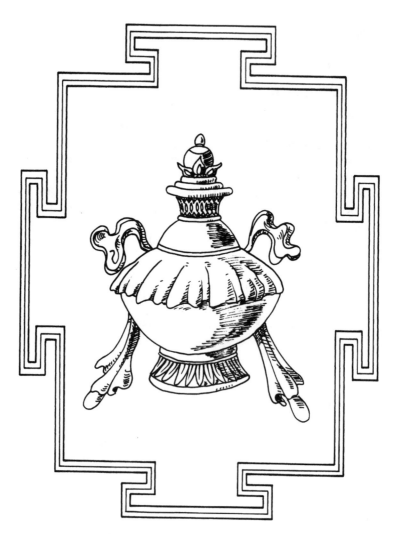

Spiritual and Material Wealth

The Urn

(Sanskrit, Kalasa)

The vase or urn (kalasa) promises the good fortune of spiritual and material fulfillment; it symbolizes the treasure of spiritual wealth. Among its treasures is the jewel of enlightenment. The satisfaction of material needs has probably always been a part of its symbolism. Consequently, it is characteristic of deities that symbolize prosperity.

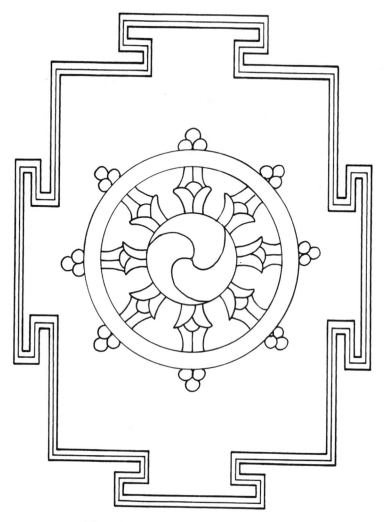

The Eight-spoked Wheel of the Law

The Wheel

(Sanskrit, Chakra)

The most important of the eight symbols of good fortune is the wheel of law, which Buddha set in motion when he began to teach for the first time (page 12).

The symbolism of the wheel is interpreted in many different ways, one of which is connected to three practices of Buddhism: (1) the hub of the wheel stands for ethical discipline, which strengthens and supports the mind; (2) the eight spokes stand for the eight stages on the path (page 71) that overcomes ignorance; (3) the rim stands for concentration, a prerequisite for staying focused when teaching.

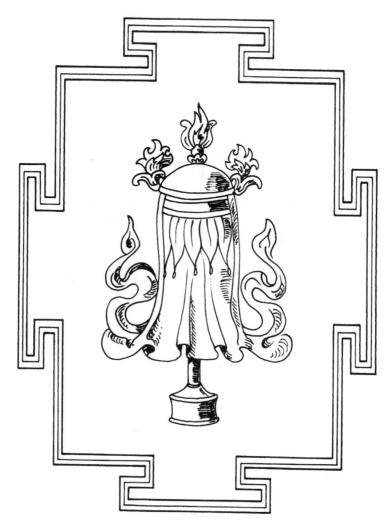

Victory over Ignorance

The Flag of Victory

(Sanskrit, Dhvaja)

The banner or flag (dhvaja) stands foremost for the victory of Buddhist teachings over ignorance. Furthermore, it announces that all spiritual obstacles have been overcome and that good fortune has arrived. This symbol is often seen in churches and temples.

Certainly, the symbolic meaning includes victory over opposing forces of all kinds, and so this symbolism has over time extended to the worldly as well.

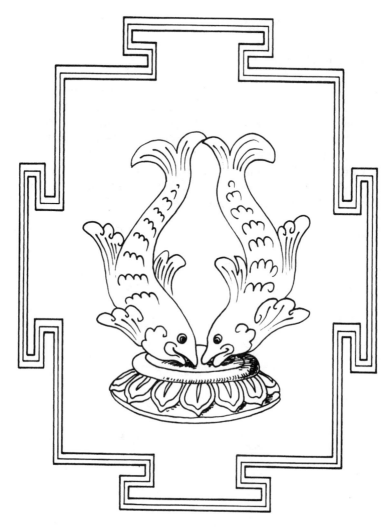

Fertility and Liberation of the Spirit

The Golden Fish

(Sanskrit, Survanamatsya)

The motif of the two golden fish on a lotus throne (page 113) symbolizes the liberation of the spirit from the ocean of samsara, the misery of earthly existence and the cycle of rebirth. The fish is also a symbol of fertility.

In Hinduism this motif represents the two sacred rivers, the Ganges and Yamuna.

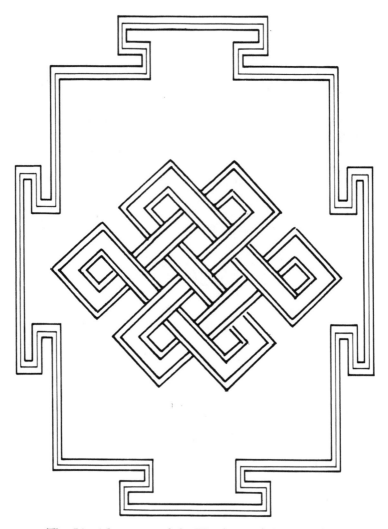

The Limitlessness of the Wisdom of the Buddha

The Infinite Knot

(Sanskrit, Srivatsa)

In Buddhism—particularly Tibetan Buddhism—the infinite or magnificent knot (srivatsa) is the classic icon for the concept of reality: the interwoven lines are graphic representation of the idea that everything in this world is interconnected and therefore independent of cause and effect. The knot also reflects the endless cycle of death and rebirth. It is a line without beginning or end that radiates both calm and movement. It mirrors infinity and the wisdom of the Buddha.

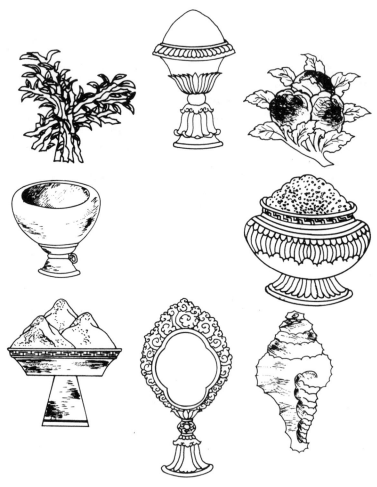

Medicine, Bael Fruit, Mustard Seeds,
Conch Shell, Mirror, Cinnabar, Yogurt, and Grass
(clockwise, starting at 12 o'clock)

The Eight Symbols That Bring Good Fortune

A second group of eight items relating to good fortune are those that bring it. They are: medicine, bael fruit, mustard seeds, clockwise-spiraled conch shell, mirror, cinnabar, yogurt, and grass.

This group of symbols, like the first, is already mentioned in the early canonical texts (11th-13th centuries, see pages 5-6). Each object exemplifies or represents a tantric stage or path of the bodhisattva, thus establishing a connection between the external, visible world and the inner, reflective world.

Behind each object stands the message that the goal is the Buddha state. To reach this goal, each being must care for his own needs as well as those of all other beings by helping them as much as possible to reach that goal. In the end, the desire (to reach the Buddha state) and the path (to it for all beings) are identical because both constitute the whole.

The symbolism of the individual objects is discussed on the following pages.

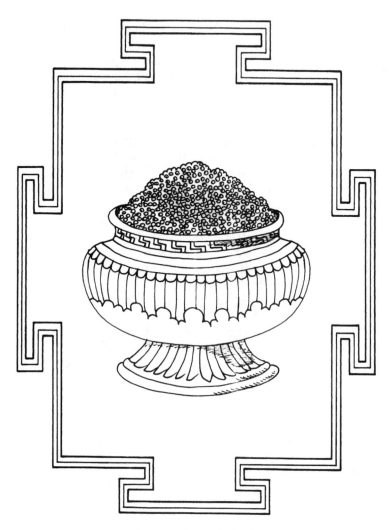

Overcoming Obstacles

Mustard Seeds

(Sanskrit, Sursapa)

Mustard seeds are connected to the wrath of the Buddhas. Wrath in this context does not suggest rage; it has more the sense of righteous indignation, a deity's powerful expression of spiritual energy.

Mustard seeds are used in rituals to drive away demons who put obstacles in the path. The seeds are dispersed during the recitation of mantras. They are also burned to promote healing and to prevent or mitigate suffering instigated by obstacle-demons.

All in all, mustard seeds symbolize overcoming obstacles by means of powerful action. Rituals involving them are thought to destroy ignorance—the demons—the root of all suffering. Destroying these metaphorical demons is actually the surmounting of barriers that are the creations of one's own mind.

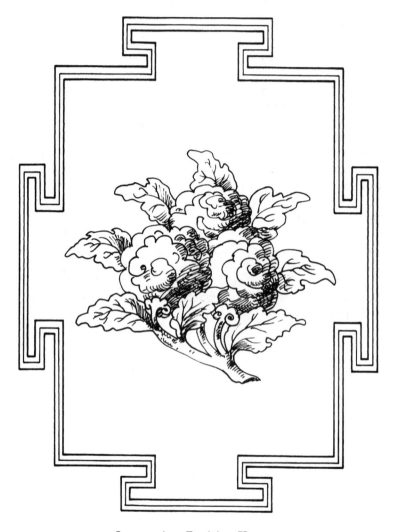

Increasing Positive Karma

Bael Fruit

(Sanskrit, Bilva)

The wood apple or bael fruit (*bilva*)—a baseball-sized fruit native to southeastern Asia that has a very hard skin and a sticky, highly aromatic pulp—is eaten in many parts of the world, more for its medicinal qualities than its taste. Offering bael fruit increases beneficial or positive karma, which brings one closer to release from samsara.

Bael fruit symbolizes the goal of recognizing emptiness and dependency, and the connection between cause and effect. It presents a challenge to avoid actions that will cause suffering and increase actions that will bring about healing. This, in the end, is the path that will bring an end to suffering.

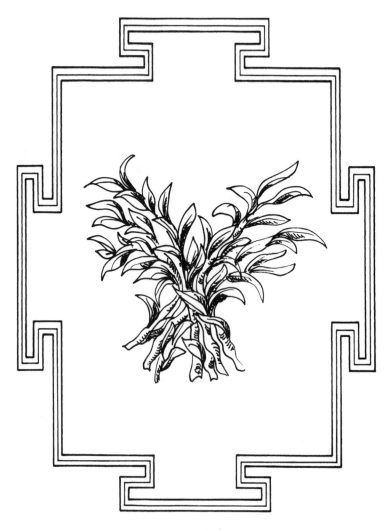

Long Life

Grass

(Sanskrit, Durva)

Grass is a symbol for a long (or longer) life and is used in life-enriching rituals. Grass, being highly resilient, is believed to be immortal and so proclaims the end of samsara, the successive death and rebirth of all beings.

What may at first glance seem a dichotomy—extending life on the one hand and the cessation of samsara on the other—is not really a contradiction in Buddhism. It takes a long time to overcome samsara and a longer lifespan allows greater progress in a given cycle.

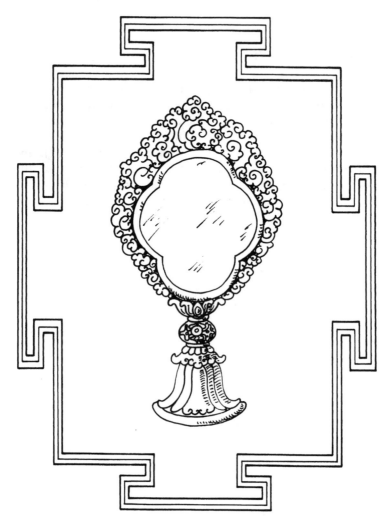

Clarity and Completeness of Perception

The Mirror

(Sanskrit, Adarsha)

The mirror is an ancient Buddhist symbol for clarity, completeness of perception, and purity of consciousness. A mirror reflects a thing objectively, but what we see in the mirror is not the thing itself. Because the object is not seen directly, it may be seen more accurately—more clearly, without judgment and with greater perspective. This may lessen the tendency to see a thing as fixed or solid and encourage better understanding. The mirror more effectively propels the mind toward insight and compassion than mere argument or lecture.

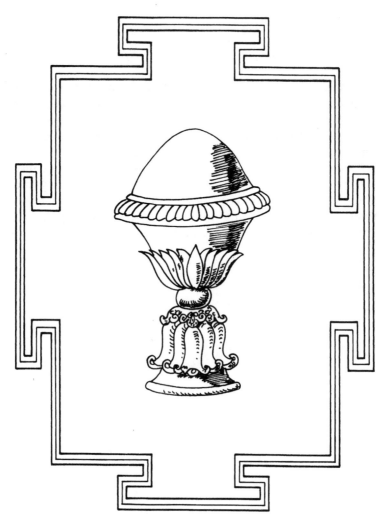

Elimination of Emotional and Physical Suffering

Medicine

(Sanskrit, Gorocana)

In this case, medicine refers to *gorocana*, literally "cow essence." This is a healing substance used in Tibet even today, obtained from gallstones in cattle (a similar one is derived from elephants). Whatever its actual healing powers, this medicine has the metaphorical ability to remove poisons on the physical as well as the spiritual plane. Healing, however, can take place only if behind the offering is the desire to purify a specific poison. In this sense, being freed from physical suffering means also being freed from suffering on all other levels and the goal is not only temporary relief but healing in the ultimate sense.

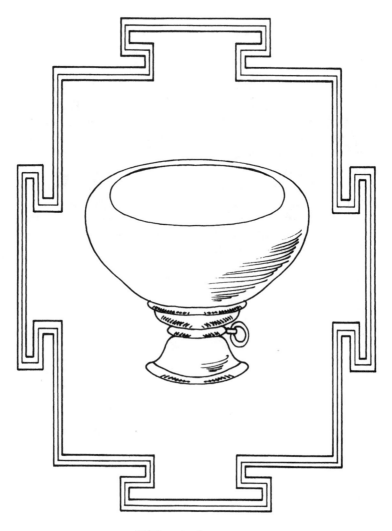

Ultimate Awareness

Yogurt

(Sanskrit, Dadhi)

The slow process of making yogurt (basically, the fermenting of milk) is an appropriate metaphor for transforming the spirit. By faithfully applying the principles of Buddhism, negative behavior (karma) is overcome and the clear nature of mind is revealed. Escape from samsara is the result and the Buddha state is reached. In order to achieve this spiritual knowledge, an offering of yogurt is made.

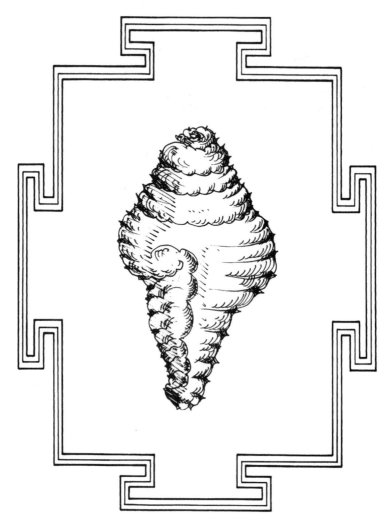

The Sound of Dharma Teaching

The Conch Shell

(Sanskrit, Daksinavartasankha)

The right-whorled conch or snail shell has the same meaning as in the earlier eight symbols of good fortune: the teachings of Buddha will spread in all directions like the sound emitted when the shell is used as a horn (pages 127, 141, 215). It promotes the spread of good deeds.

The shell makes it possible for the essence of the master's words to be heard and understood. It is said that all sounds that do not foster Buddhist teachings seem shallow when compared to the sound of the conch shell.

The master who possesses the language and understanding of the teachings does not teach the wisdom he has acquired from an intellectual, purely cognitive position, but from his enlightened recognition of reality. This is the only way by which the sound of dharma teaching is represented.

Power

Cinnabar

(Sanskrit, Sindura)

Cinnabar is a red powder composed of mercuric sulfide. In certain rituals, it is used to make a mark on the forehead called *tilaka*. It is also used as a coloring agent in paintings and mandalas.

In tantric Buddhism, red is the color symbol of power. It symbolizes the realization of power through action. Power in this context means having command of one's skills as well as one's wisdom and awareness. Properly used, these enable one to seize hold of the dharma, the teachings of Buddhism.

Plants and
Animals

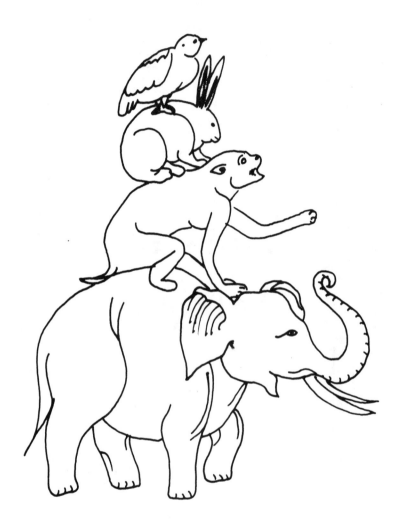

Respect and Honor

The Four Compatible Brothers

Buddha told his students the fable of the four compatible brothers so as to make clear the meaning of respect and the application of Buddhist virtue. In this way, he meant to ease his students' path to enlightenment.

The fable concerns four animals—a partridge, a rabbit, an ape, and an elephant—who are discussing their ages in relation to that of a tree. Each of the four insists that he is the oldest. In the end they agree that each one who is younger has to pay respect to the one who is older. Regarding their commitment as if it is law, everyone in the land slowly accepts it, with the result that good fortune and peace prevail everywhere.

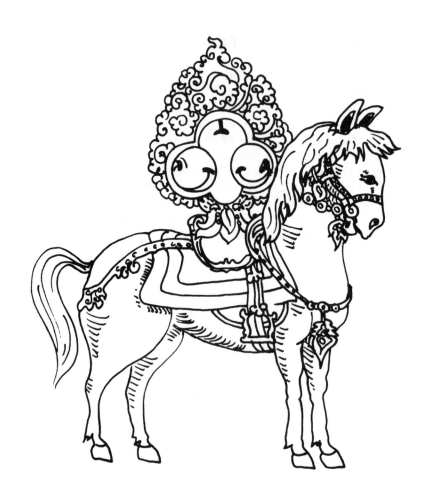

Mobility

The Precious Horse

The precious horse is one of the seven treasures of the *Chakravartin* (Sanskrit, wheelturner). The term in Hinduism refers to an ideal ruler but, in Buddhism, Chakravartin has come to mean a Buddha whose all-encompassing teachings are universally true throughout the cosmos. The other jewels of royal power are the precious queen, the precious jewel, the precious wheel, the precious elephant, the precious minister or master of the house, and the precious general.

The horse is Chakravartin's riding horse and symbolizes mobility and speed. The horse's coat is immaculately white and he is able to round the globe three times in a day.

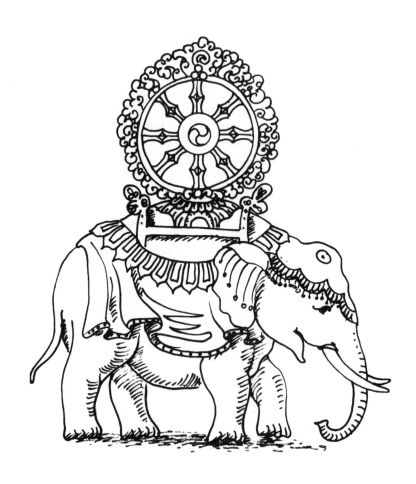

Strength and Power

The Precious Elephant

The precious elephant is another of the seven treasures of Chakravartin (page 163). The elephant projects a calm majesty much like the Chakravartin Buddha's strengths of mind—boundless aspiration, intention, effort, and analysis. By using these abilities, all stains that are the result of vices (page 32) are removed and the meaning of everything is made known.

The elephant is white and exceptionally beautiful. His task is to defeat the armies of all enemies and he does so in the water and on land throughout the cosmos. Like the precious horse, the elephant is able to move around the earth three times in a day and he always goes in the direction determined by the spirit of Chakravartin.

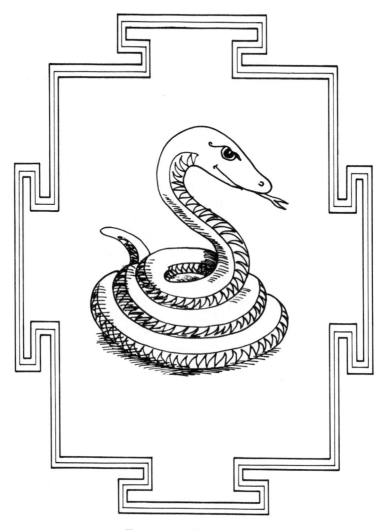

Energy and Protection

The Serpent

(Sanskrit, Naga)

Just as in other cultures throughout the world, the serpent in Buddhism has many symbolic meanings, ranging from a servant of the devil to a messenger of the gods.

In tantric Buddhism it embodies the energy that moves up through the spinal column opening the *chakras* (the energy centers of the body) one after another until it reaches the seventh (highest) chakra, above the head. This energy is called *kundalini*.

The serpent also serves as Buddha's protector and as a guard of the temple. The Buddha even entrusted the book of wisdom to the serpent to guard until human beings are capable of understanding it.

The serpent's element is water, for which reason it is seen as the mediator between heaven and earth. In times of drought, Buddhist priests beseech the serpent during rituals to bring rain. Other tantric beings are also decorated with the serpent's image.

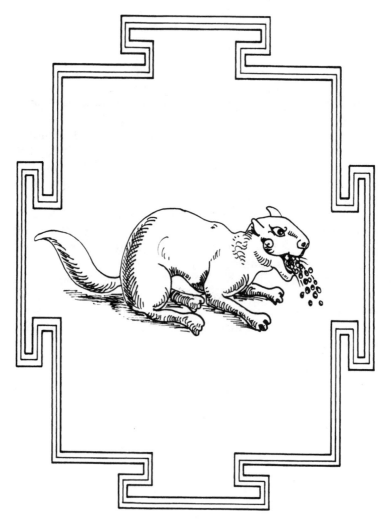

Wealth

The Mongoose

(Sanskrit, Nakula)

The mongoose (nakula), often vomiting jewels, is the most common attribute in images of Vaisravana (page 64), the god of wealth and guardian of the north. This animal is often viewed as a dispenser of wealth.

Purity

The Lotus

(Sanskrit, Padma)

The lotus represents the path that leads from ignorance to knowledge. In Buddhism it is a symbol of purity second to none (page 125). The lotus flower depicts our world, with the stem as the axis. It symbolizes as well the feminine principle (the womb of the mother), the throne of the Buddha, and the opening of the chakras, the centers (wheels) of energy in the body.

The lotus is identified with the Buddha Avalokiteshvara, the Buddha of Infinite Compassion, and with countless other buddhas and bodhisattvas. The reason is that the plant's growth habit is a peerless symbol for enlightenment: while its roots are anchored in the muck—symbolizing human desire—its leaves and flowers rise up from the bottom to turn to the sun—to enlightenment.

Legend has it that wherever the Buddha's feet touched the earth, a lotus flower bloomed.

Ashoka

The ashoka is one of a trinity of sacred flowers. The other two are the lotus and the camp flowers. It sprouts from the holy water font of the Amitayus, one of the forms in which the Buddha Amitabha appeared (see page 41).

Myrobalan

The cherry plum (myrobalan) is an astringent fruit with velvet-gray skin and laxative properties. It is an all-around healing plant and, thus, a symbol for the power of healing. In Buddhist images, the plant identifies the Medicine Buddha, Bhaisajyaguru (page 15).

Utpala

The *utpala* is a half-opened lotus flower, sometimes colored blue. It is a symbol for the stages on the path to enlightenment.

Ritual Icons

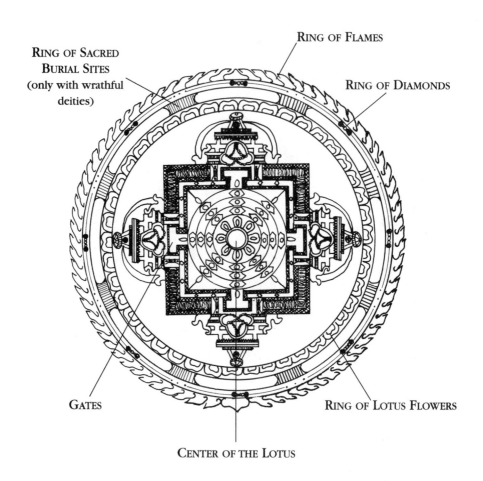

RING OF FLAMES

RING OF SACRED
BURIAL SITES
(only with wrathful
deities)

RING OF DIAMONDS

GATES

RING OF LOTUS FLOWERS

CENTER OF THE LOTUS

Representation of Cosmic Energies

Mandalas

Mandalas are symbolic representations of a number of different cosmic and other energies. Two- and three-dimensional aids for meditation, they provide models for the visualization of certain energies.

All mandalas show cosmic symbols surrounding a central point that is either the seat of a deity or the deity itself. Free from all earthly defilement, the space within a mandala is completely pure.

The Structure

The Outermost Border

The outside border is a wreath of flames in the colors of the rainbow (red, yellow, white, green, blue). It represents the supreme domain where all coarse matter is incinerated and which denies entry to the uninitiated.

The second is a border of vajras (diamond scepters), symbolizing the "non-dualistic enlightened mind" (Bodhicitta, page 8).

The third border—which appears only in mandalas of wrathful deities (Dharmapalas)—portrays eight sacred burial sites in India (Kapilavastu, Bodhgaya, Varanasi, Sravasti, Sankasya, Rajagura, Viasali, and Kusinagara) in the four main and four minor cardinal directions. At these sites ritual offerings are made to the eight states of consciousness recognized in the secret tantric teachings.

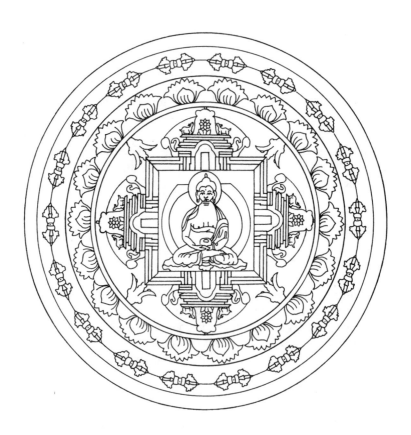

Buddha Amitabha

The fourth border shows a lotus wreath, a symbol of spiritual rebirth as well as the unfolding of a pure mind.

The Center

Inside the borders of the mandala are usually a number of different symbols, such as the wheel of teaching, a vessel containing an elixir, the eight symbols of good fortune (page 123 ff.), or the seven treasures of Chakravartin (pages 163, 165).

The center of a mandala depicts the seat of a deity who can take different forms and different attitudes, ranging from peaceful to wrathful to dreadful to frightening.

Cardinal Directions, Elements, Colors

Usually one can find in a mandala a combination of the five elements and their respective colors arranged around the center in their respective cardinal directions.

The West is red with the element fire; the South is yellow with the element earth; the East is white with the element water; the North is green with the element air; the center is blue with the element ether.

The Stupas

(Tibetan, Chorten)

In design, stupas are symbolic representations of the universe according to traditional Buddhist cosmology, though their original shape was inspired by the burial mounds of kings. Their original purpose was to enshrine relics of the Buddha's life and to commemorate his eight great deeds. Outside India, they evolved into the pagoda in East Asia and the *chorten* in Tibet, where their design is especially rich in symbolism. Their basic design is actually that of a three-dimensional mandala and the base has the same symbolism. Square, rectangular, round, and vertical shapes make up the main elements. Topped by victory flags (page 135) and parasols of enlightenment (page 129), stupas evolved into objects of formal devotion, the symbol of the all-pervasive spirit of all buddhas.

The lowest level of the base has four steps corresponding to the four contemplative practices: mindful awareness of body, emotion, mind, and law. The second level represents the four right efforts or complete abandonments: the decision to forego unwholesome thoughts and actions and to abandon those already in progress; to undertake only good deeds; and to complete those already started. The third level corresponds to the four paths of accomplishment: single-mindedness in intention, effort, thoughtfulness, and analysis. The fourth and last level of the base symbolizes the five moral faculties: faith, joyous effort, mindfulness, serenity, and mystical wisdom.

The reliquary base symbolizes the five moral powers; these have the same names as the preceding moral faculties but evolve with practice to become powers: faith, effort, mindfulness, serenity, and wisdom. The vessel itself mirrors the seven branches of the path to enlightenment: mindfulness; observance of the law; effort; joy; tranquility; concentration; and equanimity.

The spire represents the eight-fold path (page 71) and the cap, the ten powers or levels of wisdom (or the ten-fold knowledge)—complete knowledge of: the law; the karma of every being ever existent; all stages of meditative liberation; the powers of every being; the desires of every being; the actual condition of every being; the direction and consequence of all laws; all causes of mortality and of good and evil; the end of all beings; and the destruction of all illusion of every kind. The umbrella, a protection from rain, symbolizes great compassion.

The Eight Types of Stupas

There are a number of different categories of stupa, including one called the bodhi path. In this category, each of the eight stupas represents an important stage or event in the life of the Buddha Shakyamuni.

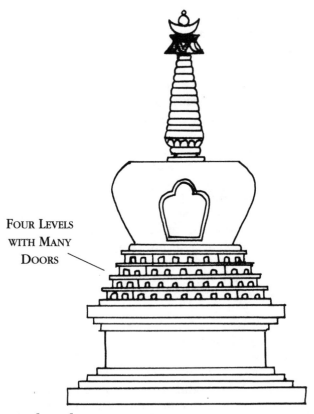

FOUR LEVELS
WITH MANY
DOORS

Bauhaudvara Stupa

This is the stupa of many auspicious doors, symbolizing the proverbial 84,000 paths to enlightenment taught by the Buddha and, alternatively, his first sermon. In reality, Buddha gave his first sermon in Sarnath, teaching there the Four Noble Truths.

182

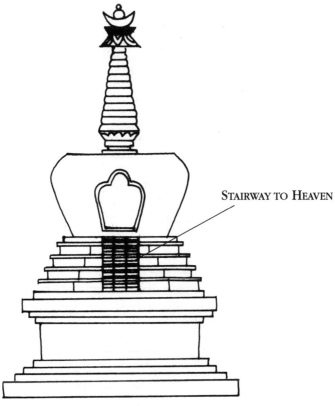

STAIRWAY TO HEAVEN

Devavatara Stupa

The *devavatara* stupa, which includes a ladder to heaven, is said to be a reminder of the visit of the Buddha as the great master of the gods. Some regard it as a reminder of Buddha's return from Tushita Heaven, where he visited his mother.

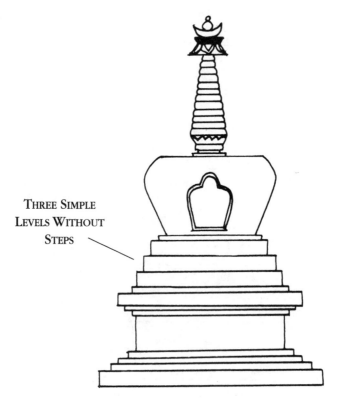

THREE SIMPLE
LEVELS WITHOUT
STEPS

Vijaya Stupa

The victory *(vijaya)* stupa commemorates Buddha's recovery from a serious illness. His disciples performed a long-life ceremony honoring the Queen of Enlightened Beings *(Ushnishavijaya)*, a goddess of long life, and he recovered.

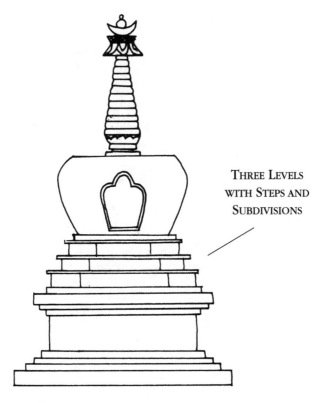

THREE LEVELS
WITH STEPS AND
SUBDIVISIONS

Pratiharya Stupa

The *pratiharya* stupa symbolizes the constancy with which
the Buddha resisted temptations when he meditated under
the fig tree in Bodhgaya.

185

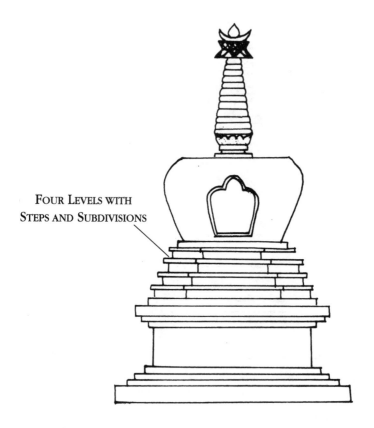

FOUR LEVELS WITH
STEPS AND SUBDIVISIONS

Antaryana Stupa

The *antaryana* stupa commemorates the reconciliation of
monks who experienced dissension caused by Buddha's
cousin, *Devadatta*, arising from his jealousy of Buddha. This
is also considered Buddha's final victory over Mara, the god
of evil.

186

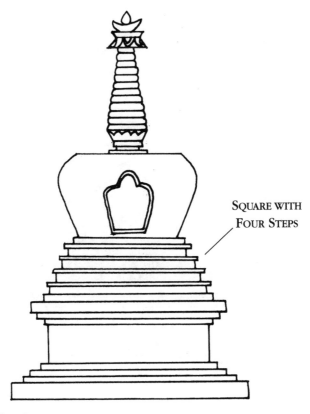

Square with
Four Steps

Mahabhodi Stupa

The *mahabhodi* stupa symbolizes Buddha's enlightenment under the bodhi tree.

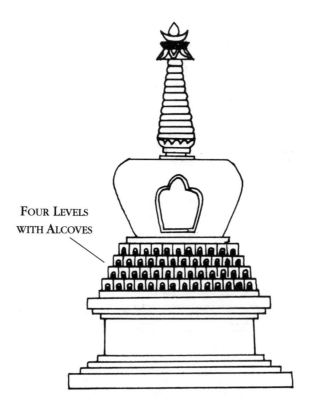

FOUR LEVELS
WITH ALCOVES

Padmakataka Stupa

The *padmakataka* stupa is a reminder of where Buddha was born, a tiny town called Lumbini, in what is now southern Nepal.

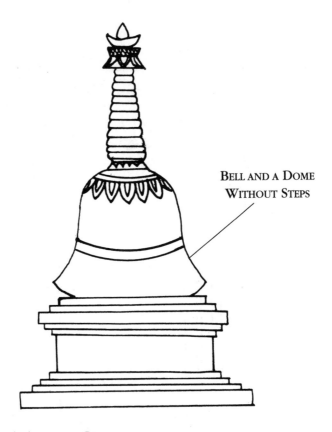

BELL AND A DOME
WITHOUT STEPS

Mahaparinirvana Stupa

The *mahaparinirvana* stupa is the symbol of Buddha's *parinirvana*, the highest stage of enlightenment.

A Stylized Depiction of the Tantric View of the World

Thangkas

Unique to Tibetan Buddhism, a thangka is a portable painted or embroidered banner or scroll made of linen, cotton, or silk; it is hung in a monastery or a family altar and is carried by lamas in ceremonial processions. Minerals provide the ground color for the fabric and plant materials the color for the shadows. Thangkas may portray Buddhas or great masters or events from their lives. They are usually rectangular in shape; square ones generally feature mandalas. Thangkas are categorized by their background color and serve as aids to and focuses for meditation. Thangkas have a standard design usually including these parts:

1. This section is considered the door, root, or sometimes the source. The rectangular shape symbolizes the cosmic ocean and embodies the path to enlightenment.

2. The fabric borders above and below the "roots" symbolize the ten stages of inner purity and spiritual enlightenment. In addition, they represent the path to enlightenment and the element earth.

3. and 4. The left and right fabric borders of the middle portion represent the esoteric or tantric form of Buddhism (page 205) as well as the attainment of higher spiritual knowledge by a layperson (3) or a master (4).

5. The upper horizontal fabric border symbolizes heaven and nirvana, the realm to which everything in the end will return.

6. The inner frame surrounding the actual picture features red and yellow rainbow colors and represents the radiant emanation of the deity.

7. The fabric cover protects the thangka from the gaze of the uninitiated and from environmental pollutants like smoke.

8. Two pieces of fabric weighted with sand hold the cover (7) in place to prevent it from moving, and thereby exposing the thangka.

9. The handles—usually made of gold, silver, or ivory—are ornaments. They are connected by a rod that keeps the thangka from folding.

The thangka frame has one function: to underscore the effect of the picture. In Western tradition, deliberately selected combinations of frame and picture may express certain esthetic sentiments. The fabric border around a thangka, however, has religious significance inseparable from the picture itself: picture and frame complement each other and represent a symbolic as well as artistic whole, because the dividing line between the two is always fluid.

The border—where the different fabrics are clearly defined—mirrors the basic structure of the Tibetan world-view at the same time that it makes a statement about the spiritual themes graphically depicted. There are special frames that have historic as well as geographic meaning. The Tibetan example is generally accepted as the standard.

According to Tibetan tradition, the creation of a thangka is a visionary art often involving rituals and meditation exercises. The process may take several years.

Weapons

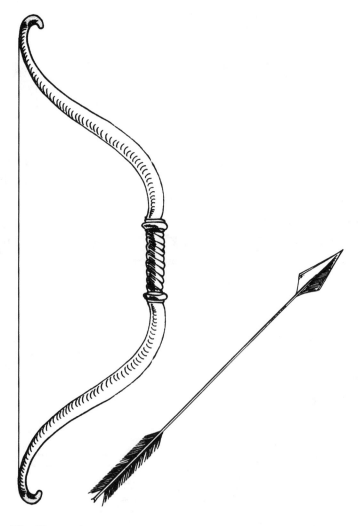

The Bow of Compassion and the Arrow of Knowledge

Bow and Arrow

Sara and Capa

The bow is the symbol central to the virtues of Mahayana (Greater Vehicle, page 9). It is usually depicted together with the arrow of knowledge (or alignment with the Absolute) and is considered the signpost to absolute emptiness (sunyata), the highest form of enlightenment.

Together, the bow and arrow symbolize the accuracy of the intellect fueled by determination and will power. Along with the sword (page 199) and the book (page 233), they are distinguishing features of the four-armed Manjushri (page 51). They emphasize verbal as well as philosophical keenness.

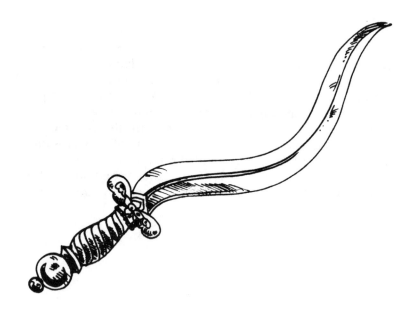

Curved Sacrificial Knife

(Sanskrit, Kukri)

The curved flaying knife is modeled on the Indian butcher
knife used to skin animal hides. It is used during rituals to
cut symbolically through the veins or roots of enemies.

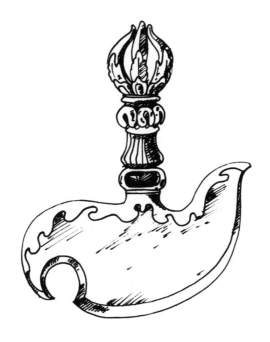

Vajra Hatchet

(Sanskrit, Kartika)

The *kartika,* or crescent-shaped chopper, symbolizes the piercing edge of wisdom that cuts up ignorance and attachments to worldly things. It eliminates the six basic transgressions: ignorance, hate, pride, greed, doubt, and wrong outlook.

The Sword of Wisdom

Flaming Sword

(Sanskrit, Khadga)

The flaming sword symbolizes the knowledge that severs and burns away the knot of ignorance. In addition, it can keep danger at bay.

It is used by Jizo, a bodhisattva who goes fearlessly anywhere his help is needed by those on the path to enlightenment. He has a special affinity for women, children, and travelers. He is characterized chiefly by benevolence, determination, and unflagging optimism.

Jizo is considered a divine advocate, as his pleas can overturn judgments. He comes to the aid of the condemned by using the *khadga* to open the door of hell.

The Rope of Dharma

Rope

(Sanskrit, Pasa)

The *pasa* (noose or lasso) is a symbol for catching the spirit as it tries to escape. The rope forces the spirit to keep to its purpose. It captures the meditator and so helps him remain focused and aware of the reason for meditating. It allows him to keep his thoughts from wandering.

The rope also serves spiritually to leash the enemies of the teachings—the demons—to the dharma. The wrathful gods (dharmapalas) often bear a rope.

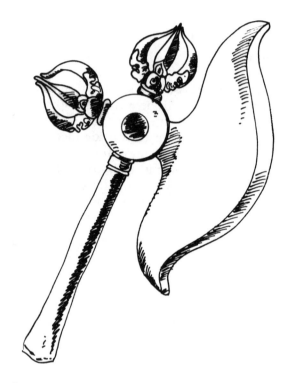

Tantric Ax

(Sanskrit, Parasu)

Buddhist belief holds that this ax will sever the shackles of ignorance that bind a being to samsara, the endless cycle of death and rebirth.

Trident

(Sanskrit, Trishula)

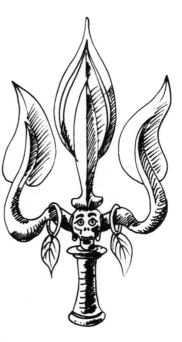

This ancient symbol has long been an element in Hindu art, through which it flowed into Buddhist art. In Buddhism, it symbolizes control over the three central channels of the subtle nervous system: the main channel is the *susuma* and the secondary channels are *ida* (left) and *pingala* (right). In addition, the *trishula* is the identifying feature of the wrathful deity Mahakala, who was originally a demon. After Manjushri (page 51) paralyzed him, Mahakala changed into the protector of Buddhism.

In Hinduism, trishula identifies Shiva, the one who demolishes the world. Trishula is used to overcome the three basic vices: desire, aggression, and ignorance. The two prongs uniting in the center flame symbolize in addition the unity of method and wisdom; the forsaking of the two extremes of samsara and nirvana; and the ultimate union of absolute truth and relative truth.

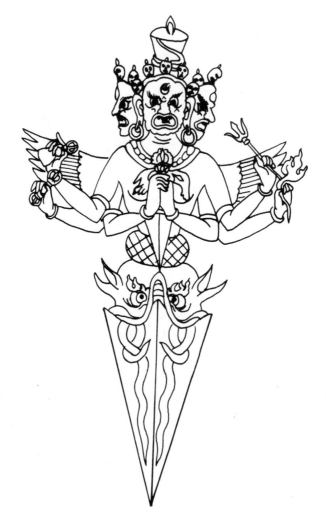

Magic Dagger

Dagger

(Sanskrit, Vajrakila; Tibetan, Phurbu)

The *phurbu* is a ceremonial dagger used to transfix demons. Its name in Sanskrit means diamond peg or nail, and it can cut as well as nail in place. It has a three-sided blade with a shape suggestive of the pegs driven into the earth to hold the rope stays of a tent. Its intended ritual purpose may be to do the same with a demon or enemy of Buddhist teachings.

The handle of the *vajrakila* usually features the head of the deity *Hayagriva*, a wrathful form of Avalokiteshvara (page 49). Hayagriva is an important deity of protection in the *Sakya* and *Nyingma* schools.[3]

[3]*Members of Tibetan/Tantric Buddhism have separated into four schools: the Nyingma School (representing the oldest form of Tibetan Buddhism in which still exist remnants of the pre-Buddhist religion, Bon); the Kagyu School, dating from the 11th century and emphasizing mysticism and meditation; the Sakya Sect, also from the 11th century; and the Gelugpa (also called the Yellow-hat) Sect, founded by Tsongkhapa in the 15th century, in which great emphasis is placed on the study of scripture. Its best-known representative is the Dalai Lama.*

Musical
Instruments

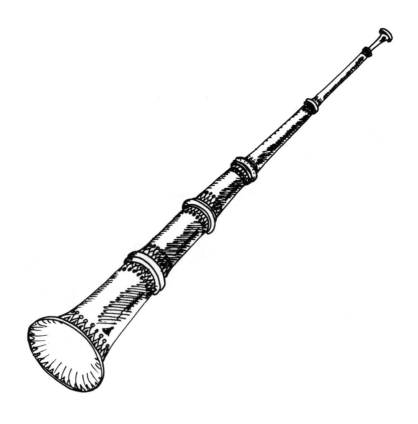

The Sound Connection to the World Beyond

The Horn

Radong

The *radong* is a huge horn comparable in size to the alpenhorn, with a deep, mournful sound. Also called the *tung*, it is part of a ritual orchestra.

Combining the radong with other indigenous instruments, this orchestra can produce sounds identical to the internal voices of human beings. The instruments' vibrations can be brought into harmony with those inner voices and, if this happens, one will hear the sounds of the universe beyond, where the Buddha lives. The effect of this extraordinary experience is very strong.

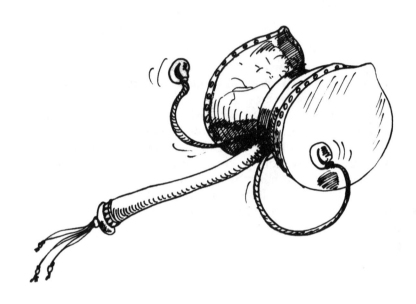

Teacher of Immortality

The Double Drum

Damaru

The *damaru* is shaped somewhat like an hourglass with two opposing faces (the drumheads) often laced together with cord, and two sticks or knots that are attached by ropes or cords. Turning or twisting the drum rapidly produces a rattling sound as the knots on the ends of these cords strike both heads. The sound they produce teaches transitoriness. At the same time it celebrates the victory over suffering reached by practicing the secret art of tantra yoga.

Like the radong, the sound of the damaru is identical to internal human voices. The drum helps one hear these voices, but it requires long exercise. The harsh, loud sound is intended to open the eyes of all human beings who are asleep to the knowledge of true reality.

The Trumpet

Kangling

The *kangling* is a small trumpet originally fashioned from the human thighbone. Its sound is said to drive out evil spirits and negative influences during Tibetan Buddhist ceremonies. This curved horn, sometimes made from hand pounded copper, typically accompanies chanting and the damaru drum.

212

The Rattle

Khakkhara

The rattle is the identifying symbol of Buddha's two most favorite disciples, *Sariputra* and *Maudgalyayana*. It was one of the few material possessions allowed to the Buddhist monk. The *khakkhara* nowadays has a solely ceremonial function, but originally, it served the mendicant monk to drive away evil spirits and to alert small animals that might cross his path, so as to avoid any involuntarily injury to them. The khakkhara's sound also allowed monks to announce their arrival to villagers without having to speak.

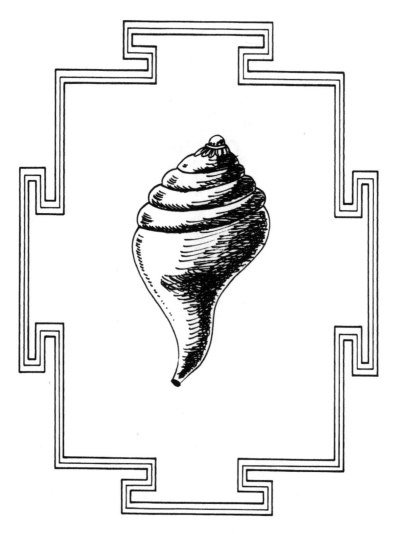

Heralding the Splendor of the Teachings

The Conch Shell

(Tibetan, Dun)

The conch shell horn (pages 127, 141, 155) is one of the simplest and most impressive musical instruments used in Buddhist rituals. All that is needed to play such an instrument is to find a suitable shell and drill a hole in its side; the larger the hole, the deeper the sound. The sound of the shell is likened to that of the voice of fog.

Rhythm

The Frame Drum

This drum is made from a thin, flexible length of wood, the ends of which are brought together to form a circle. Both sides are then covered with leather and a handle in the shape of a pointed vajra (diamond scepter) is attached. A curved piece of bamboo or reed serves as a stick.

The design of this drum may have originated with the shaman, but was adapted by Buddhism as a musical instrument. As an accompaniment to chanting, its constant, prolonged beating can enhance the meditative state. Today it is usually found only in Tibet.

In Harmony with the Gods

The Cymbals

(Tibetan, Tingsha)

The sound created by the *tingsha* is a plea to the gods—
whom the drums have called down to earth—to remain
here. They are rung to start or end a meditation or teaching,
or simply to create a moment of quiet concentration. The
two cymbal-shaped metal disks are struck together at right
angles, producing a loud sound with a unique shimmering
quality.

The cymbals are made of brass and have a concavity in
the center to which a cord is attached. They are played by
holding the cord and letting the bells strike each other.
Sizes vary greatly.

Ritual Icons

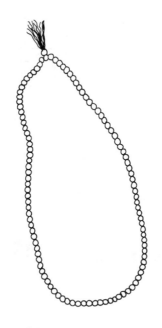

The Prayer Necklace

(Sanskrit, Akshamala)

This Buddhist "rosary" is a prayer necklace with 108 pearls, each representing a mantra or invocation. A mantra is one or more sacred syllables or sounds that are chanted continuously during meditation. It represents the essence of a being and calls forth that being. A mantra stores the essence of creation; it is the primeval sound that gives form to relative experiences and thereby fulfills the highest reality of emptiness.

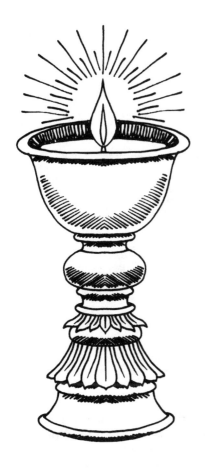

The Light/
The Butter Lamp

(Sanskrit, Dipa)

Light in Buddhism is a phenomenon that fills the whole of the universe. In addition, light is connected to good karma and its effect on life after death. Light is said to guide the deceased or his or her soul to the joys of the world beyond.

Light is a symbol as well of the highest reality and thereby one of the most important Buddhist ritual offerings. Candles that incorporate such precious substances as butter (*ghee*) underscore the importance of the offering. *Dipa* is also the name for the lamp or vessel that contains the burning fuel.

The Flywhisk

(Tibetan, Chamara)

The flywhisk, made from oxen, deer, or yak hair, was originally a symbol of secular power. In Buddhism it took on the meaning of spiritual authority. Particularly in Zen Buddhism, it signifies the authority of the master over the student.

Furthermore, the whisk is a reminder of all-encompassing compassion in its purpose to drive away insects without harming them.

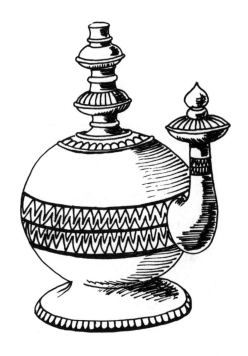

The Holy Water Vessel

(Sanskrit, Kamandalu)

The holy water from the *kamandalu* is poured into the palms of people attending a Buddhist ritual. In a broader sense, the water may represent the nectar of immortality, an important element in special initiation rites.

Skull Cup or Bowl

(Sanskrit, Kapala)

The *kapala* is a symbol of the wrathful deities (dharma-palas), highlighting the victory of light over demonic forces. It signifies the power of enlightenment to overcome even death, transforming it into everlasting life.

The kapala is a bowl or cup made from the top of a human skull and used as an offering vessel. It contains a mixture of blood and wine representing the blood, eyes, ears, and tongues of demons that is transformed in the bowl into the nectar of immortality.

The vessel features in tantric Buddhist rituals where today wine is used instead of blood. The use of human bones symbolizes the belief in the impermanence of life held by adherents of tantric Buddhism.

The Monk's Robe

(Sanskrit, Kasaya)

The robe or cassock is one of the six personal items of a monk. The other five are a beggar's bowl, a knife (for shaving), a needle (for mending the robe), a belt, and a linen cloth for filtering from drinking water any tiny living organisms that might otherwise be swallowed.

Originally the robe consisted of a reddish-brown stole held in place with rope made from pieces of cloth. The number of cloth pieces depended on the function and rank of the wearer. Later this stole became a liturgical garment, and today it is worn over the normal robe. It symbolizes the transfer of authority from master to student.

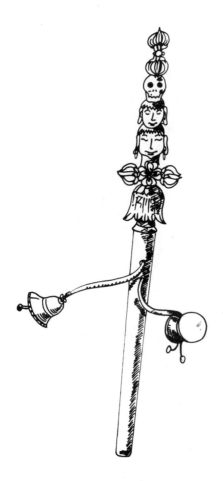

The Staff

(Sanskrit, Khatvanga)

The *khatvanga* is a ceremonial object and a tantric token of dignity, symbolizing the rule over subtle bodies of energy and, thus, the utmost enlightenment. A khatvanga may sometimes have no staff, particularly when it is used strictly for rituals.

The khatvanga features the bell and vajra, which together embody the union of wisdom and compassion (page 235). This is generally crowned by a carving of three human heads, fresh, dried, and a bare skull, symbolizing the conquest of the three poisons of lust, hate, and delusion. Some staffs have a three-pointed tip signifying mastery over the three central channels of the yogic subtle nervous system (page 203).

The Prayer Wheel

(Tibetan, Khorten)

The prayer wheel is an instrument peculiar to Buddhism and is very characteristic of its religious notions. Frequent reading of the holy books and the reciting of sacred phrases is regarded as a means of overcoming karma and being delivered from samsara. For followers who were largely illiterate, the mere turning of a rolled manuscript came to be considered an efficacious substitute for reading it.

The *khorten* contains parchment on which a mantra or sacred text is written. The cylinder is turned clockwise during prayer, each turn sending a mantra out to the world. As is the case with many rituals, an unshakable belief in the effectiveness of the ritual is of utmost importance.

The Mani Stone

A *mani* stone is a sacred object for adherents of Tibetan Buddhism on which prayers or sacred images are inscribed. Walls and mounds of them abound throughout Tibet, the largest of them said to be a mound of 10,000 cubic meters (353,100 cubic feet) and to contain more than two billion stones. The stones are inscribed in Tibetan with the universal mantra of Avalokiteshvara, "om mani padme hum," from which they derive their name. A Buddhist believer prays while walking clockwise around the mound. Pilgrims also lay such stones in front of monasteries. Mani stones exemplify how a folk art can be closely related to the spiritual life of a people.

The Beggar's Bowl

(Sanskrit, Patra)

The Sanskrit word *patra* translates as "vessel of appropriate size," implying that the bowl will hold enough to satisfy one's needs. The beggar's bowl is more than a symbol of release from craving and desire; it symbolizes the dedication of monks to the dharma.

This bowl plays a vital role in the life of a beggar monk: a monk has only one bowl, which is close to irreplaceable. Should the bowl break or get lost, the monk will be unable to beg for food and will starve.

Peacock Feathers

(Sanskrit, Mayurapiccha)

Peacock feathers are symbolic of the forgiveness of all sins and are thus a sign of good luck. They are also said to drive off evil spirits.

The Sacred Book

(Sanskrit, Pustaka)

The sacred book is a symbol of learning, wisdom, and insight, particularly of *The Perfection of Wisdom That Cuts Like a Diamond* (Prajnaparamita sutra, page 5). Wisdom is the most important spiritual power in Buddhism because only wisdom can liberate us from suffering.

This book is different from what we would know as a book in the West: it is single sheets of parchment paper placed between two wooden covers, held together by a ribbon. The sheets are covered with writing from left to right, diagonally, and on both sides.

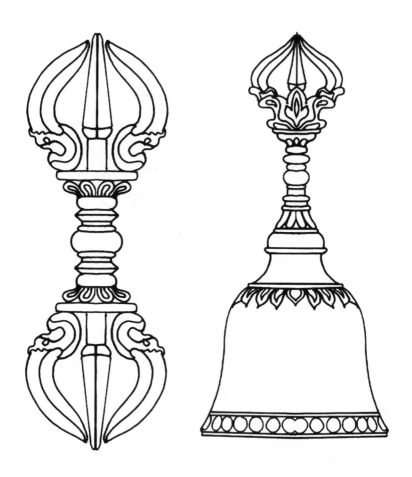

The Way and the Goal

Vajra and Bell

(Tibetan, Dorje and Drilbu)

In India, the vajra (diamond scepter) symbolizes the highest energy of Indra, one of the three most important gods in Hinduism, the others being Brahma and Shiva. It is used for punishment by this god of war and thunderstorms.

In Mahayana Buddhism, the vajra is the symbol of compassion, the most powerful energy in the universe. In tantric Buddhism, it is the symbol of compassion as the active quality of kindness, rather than mere sympathetic feelings not transformed into action. Compassion refers to action that is exactly consonant with whatever is occurring and that is not self-referential. It is also the Buddhist symbol for the masculine principle.

The bell (*ghanta* in Sanskrit) symbolizes the comprehension of emptiness in all its forms. The bell is also a symbol of transitoriness and the feminine principle.

Together they symbolize the path to enlightenment, the journey and the goal as one.

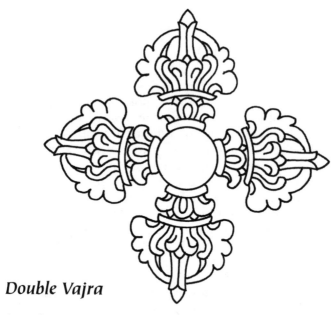

Double Vajra

(Sanskrit, Visvavajra)

The vajra is generally two-sided but the *visvavajra* or the double thunderbolt has four heads representing the four Dhyani Buddhas. Of these, it is associated primarily with Amoghasiddhi, lord of the north, the Karma Family buddha whose name means Unfailing Accomplishment. The double dorje or crossed vajra represents the indestructibility of all phenomenal essence. It is also sometimes interpreted as the Wheel of the Good Law. It serves as a symbol of harmony, unchangeableness, and all-knowingness.

Oracle Vessel

Throughout the search for divine assistance a believer may call upon an oracle. The seeker shakes the oracle vessel, from which a slip of paper with a number will fall out. A priest exchanges this slip for a horoscope that, if negative, is pinned to a sacred tree that will nullify its effect.

Index